IMAGES
of America

AUSTIN
TEXAS

IMAGES
of America

AUSTIN
TEXAS

Karen R. Thompson and Kathy R. Howell

ARCADIA
PUBLISHING

Published by Arcadia Publishing
Charleston, South Carolina

Printed in the United States of America

Library of Congress Catalog Card Number: 00-108634

For all general information contact Arcadia Publishing at:
Telephone 843-853-2070
Fax 843-853-0044
E-Mail sales@arcadiapublishing.com
For customer service and orders:
Toll-Free 1-888-313-2665

Visit us on the Internet at www.arcadiapublishing.com

ADDITIONAL BOOKS BY THE AUTHORS INCLUDE THE FOLLOWING:

Defenders of the Republic of Texas. Austin, Texas: DRT Press, 1987.

Historical Round Rock Texas. Austin, Texas: Eakin Press, 1985.

Historical Williamson County, Texas. Austin, Texas: Nortex Press, 2000.

CONTENTS

ACKNOWLEDGMENTS

The photographs in this book have come from many sources. Folks from across Texas, some family and old friends, and some new friends have been very generous to loan us their photographs.

We owe a debt of gratitude to the following people who allowed us the use of their photographs: Frances Archer, Danny Camacho, Ursula Carter, Bee Crenshaw, Imogene Dunlap, Michael Emery, Tom Flinn, Lel Hawkins (and her late husband Jerry Hawkins), Mary Hodge, Christine Mason, Carl McQueary, Mr. and Mrs. A.E. Palmquist, Tom Rogers (and his late father Thomas R. Rogers), Forrest Scott, Cynthia Treckmann, Betsy Warren, Julia Whatley, Ward Winnette, and Ken Wukasch. Editing and computer work was done by Jonathan B. Howell and Kathy Kidd Bohula.

It has been a pleasure as a mother/daughter team to work on this publication. Karen's grandfather, Kathy's great-grandfather, Charles P. Luck, was one of Austin's early photographers, from the 1890s through the 1930s. His early photographs sparked our interest in early Austin pictures.

We dedicate this book to our family, David and Mason Thompson, and Jonathan B. Howell for their support and patience.

Karen R. Thompson and Kathy R. Thompson Howell.
September 2000

INTRODUCTION

The Republic of Texas was established on April 21, 1836, when the volunteer Texian Army, under the command of General Sam Houston, defeated Mexican General Santa Ana at the Battle of San Jacinto on Buffalo Bayou.

One of the first tasks of this new republic was to select a site for the capital city, and that was accomplished in 1839 when Austin was laid out along the banks of the Colorado River. Austin has remained the capital since statehood on February 19, 1846, when Texas became the 28th state in the union.

The hilltop was reserved for the capitol building, and a wide Congress Avenue ran south to the river. Since the current capitol building was completed in 1888, it has dominated the Austin skyline.

In addition to a capital city, the Republic of Texas called for the establishment of a university. In 1883 the University of Texas opened with 218 students, and in 2000, it has an enrollment of over 50,000—the largest in the United States. Along with state government, UT has defined Austin, both in economy and style.

Austinites come in all types, from governors and mayors to statesmen and students. Most women supported suffrage, and "Ma" Ferguson was the second woman governor in the United States. Grassroots organizations such as "Save Our Springs" demand the preservation of the 170,000 year old Barton Springs and in contrast, new millionaires are created every day from the high-tech industry. Austin is indeed as varied and unique as these photographs reveal.

One

The Texas Capital

Stephen F. Austin brought the first three hundred families from the United States to the Mexican territory of Texas in 1821. This set the stage for pioneer settlers to gain independence on April 21, 1836, at the Battle of San Jacinto. Austin was selected as the capital of the Republic of Texas.

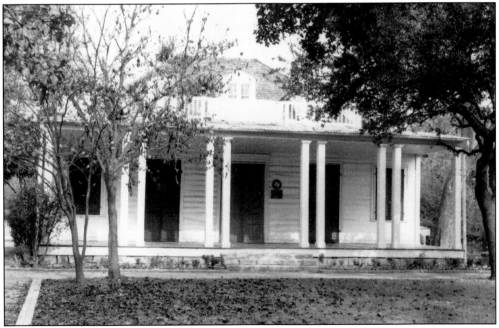

In 1839, King Louis Philippe of France sent Count Jean Pierre I. Alphonse Dubois de Saligny to the Republic of Texas to investigate whether the French government should recognize Texas as an independent nation. Count de Saligny informed the King, "Texas will bring great advantages to France for many years to come." On September 25, 1839, France recognized the Republic of Texas by signing a Treaty of Amity, Navigation, and Commerce.

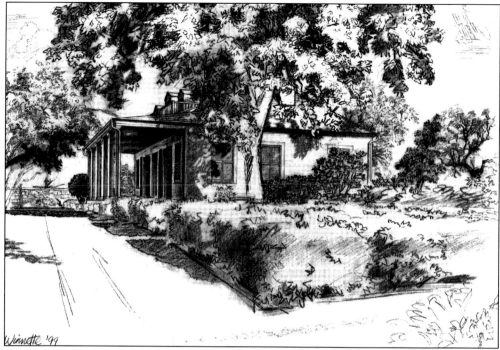

When de Saligny arrived in Austin in 1840, he found only log buildings and animals running loose on dirt roads. He purchased land, and by the middle of 1841 had built the "French Legation" embassy from lumber hauled by wagon from Bastrop. De Saligny left Austin and by 1848, Dr. Joseph W. Robertson had purchased the house. The Robertson family sold it to the Daughters of the Republic of Texas in 1948 and the DRT continues to operate it as a museum. (Copyright Ward Winnette, 1999.)

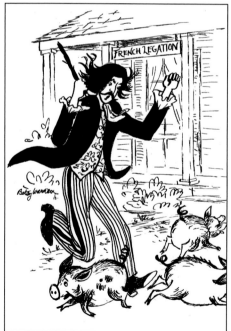

The most interesting French Legation story is referred to as the "Pig War." Count de Saligny fed corn to his horses, and the pigs of innkeeper Richard Bullock would trample down the stable fence to feed on the corn. Arguments ended when de Saligny's servant Pluyette killed many of Bullock's hogs on the morning of February 19, 1841. Bullock made a claim to the Republic of Texas government for payment of his hogs and the Count left town for a ten-month stay in New Orleans. (Courtesy Betsy Warren.)

10

Judge Edwin Waller, Austin's first mayor, also receives credit for laying out the city of Austin with wide avenues and streets sectioned in a square. The Congress allowed Waller $113,000 in funds to create the capital city. He hired two hundred raw recruits of every race, mostly inexperienced, to do the work. One night, Native Americans raided the work camp on Waller Creek and scalped two of the men. (Courtesy Lel Hawkins.)

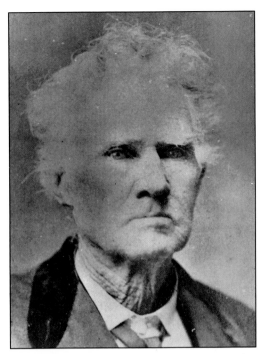

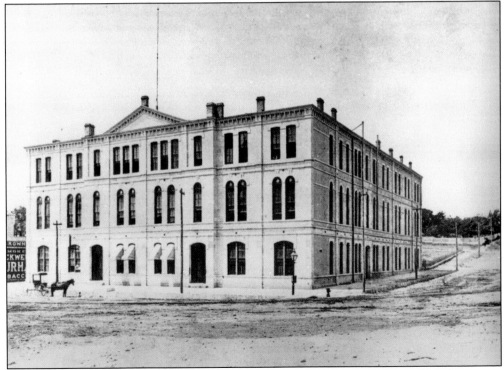

This building was erected in 1883 as the "temporary capitol." It was located on the corner of Congress Avenue and 11th Street. After the present capitol was built in 1888, this building served as Austin's first vocational school. It burned to the ground in 1899. (Courtesy Lel Hawkins.)

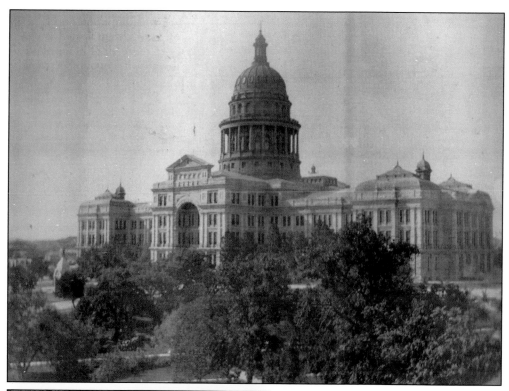

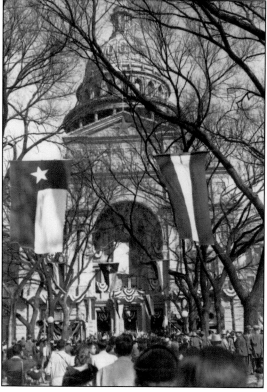

Texas needed a proper capitol building, but had no funds. In 1875 Congress provided that "three million acres of Public Domain are hereby appropriated and set apart for the purpose of erecting a new State Capitol". In 1882, after surveying, the land was traded to Abner Taylor, Amos Babcock and Company for building the capitol. Their land became famous as the XIT Ranch, and Texas acquired the largest capitol building in the United States without spending any public funds.

Governor Allan Shivers is shown at his inauguration on January 20, 1953. Governor Shivers (1907–1985) had first been elected lieutenant governor in 1946, was re-elected in 1948, and became governor upon the death of Governor Beauford Jester. He went on to serve 7 and one-half years as governor. (Courtesy Tom Rogers.)

The Texas Capitol Building is pictured here at night. Since its completion in 1888, it has been the major attraction in Austin.

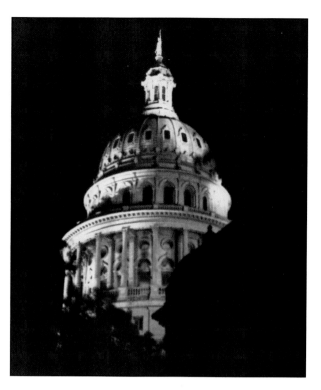

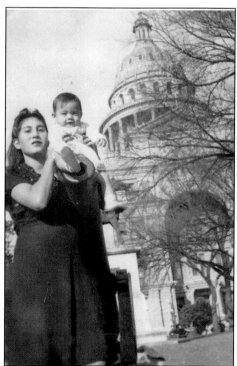

Ada Trevino is shown with her son at the capitol. (Courtesy Danny Camacho.)

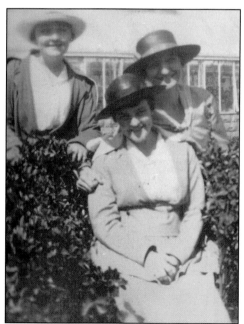

These young ladies were enjoying an outing on the capitol grounds in 1916. This greenhouse, originally used by the gardeners, was later moved to the state cemetery on Navasota Street. (Courtesy Carl McQueary.)

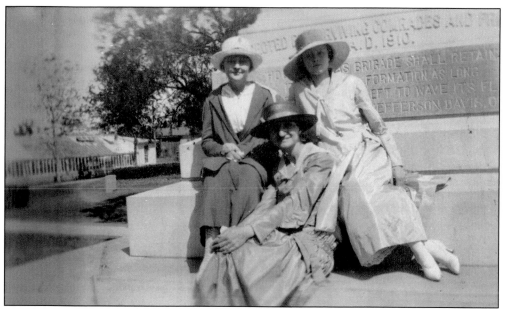

These ladies are resting on the capitol memorial monument to honor the Confederate States of America and those men who died in service to the Confederacy. Not visible in this 1916 photograph are the fine bronze figures, including Jefferson Davis, done by sculptor Frank Teich. (Courtesy Carl McQueary.)

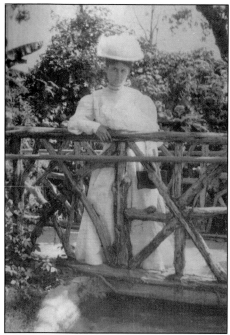

This bridge was a favorite spot to have a photograph taken on the capitol grounds during the first half of the 1900s. This 1915 photo shows some of the beautiful garden areas. (Courtesy Lel Hawkins.)

The capitol pond and water area flowers were outstanding. Gardeners decorated with enormous hanging baskets that included Staghorn ferns. (Courtesy Lel Hawkins.)

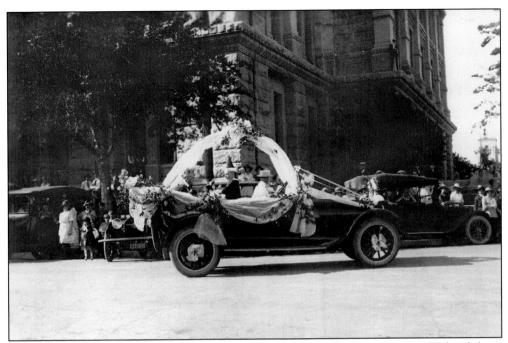

Nearly all of Austin's parades culminated at the capitol grounds. (Courtesy Ken Wukasch.)

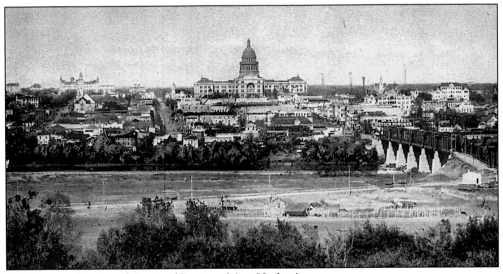

This is an early view of Austin. (Courtesy Mary Hodge.)

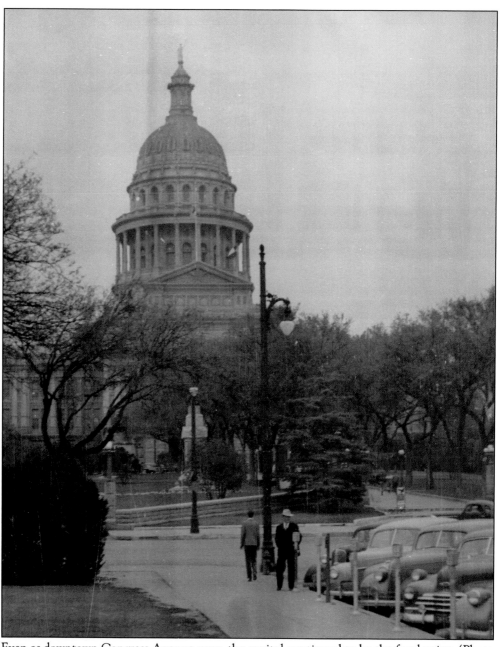

Even as downtown Congress Avenue grew, the capitol continued to be the focal point. (Photo by Jerry Hawkins.)

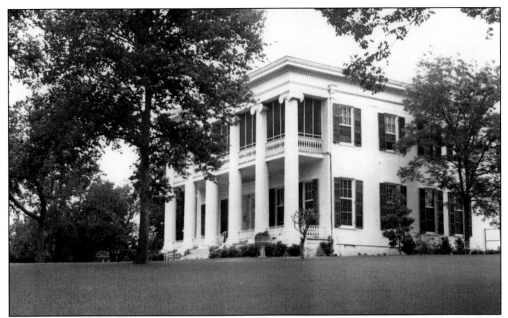

The Texas Governor's Mansion, at 1010 Colorado Street, was built in 1855–1856 for about $17,500. It was designed by Richard Payne and constructed of brick by master-builder Abner Cook. The family of Governor E. M. Pease was the first to live in the mansion, and it has been home to every governor since that time. Although each governor's wife has contributed to the home or grounds in some way, Mrs. John B. Connally (Nellie) made vast improvements to the grounds. It is the oldest governor's residence west of the Mississippi River. (Courtesy Tom Rogers.)

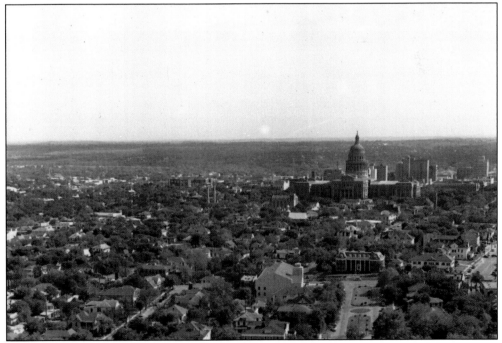

This is how Austin looked in 1952. (Courtesy Tom Rogers.)

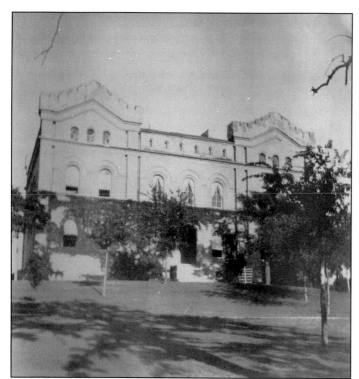

Built in 1856, the Old Land Office Building, at 112 East 11th Street, is the oldest structure on the capitol grounds. The castle-like (Gothic revival style) building was designed by German immigrant Conrad G. Stremme, who later became a draftsman in the land office. The building is now the capitol visitors' center. (Courtesy Lel Hawkins.)

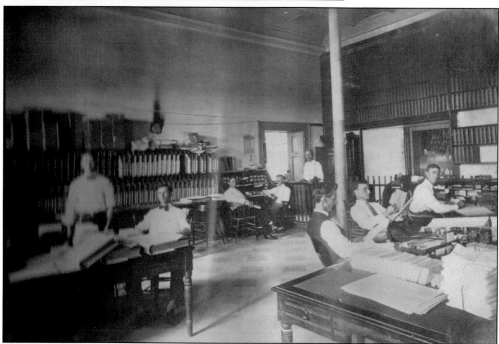

This inside view of the Old Land Office Building was taken prior to 1917 when the office moved to a new building. At that time, the Daughters of the Republic of Texas and the United Daughters of the Confederacy, Texas Division, began operating the building as a museum. Both patriotic groups moved out in the 1990s. (Courtesy Lel Hawkins.)

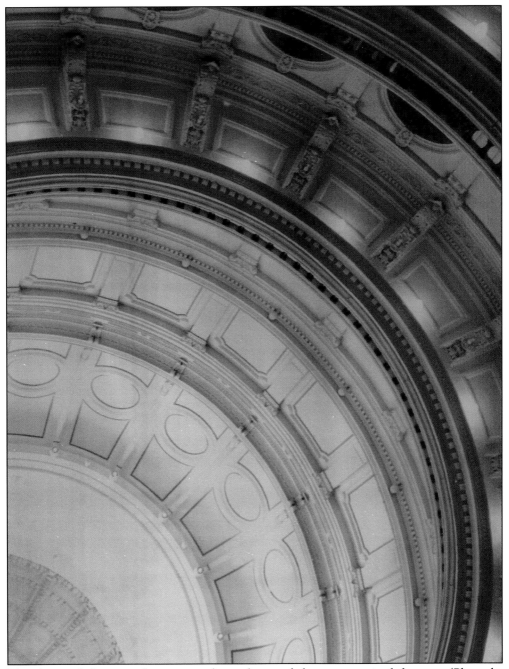

The dome of the capitol is spectacular and one of the most noticed features. (Photo by Jerry Hawkins.)

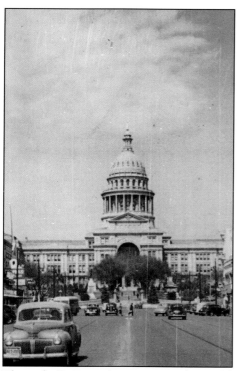

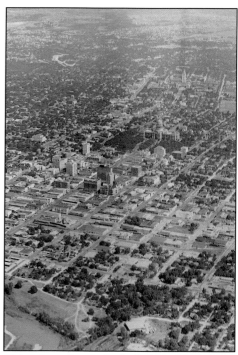

The wide Congress Avenue gives a beautiful view looking north from the Colorado River.

This is how Austin looked about 1950. Note that Interstate Highway 35 had not yet been built east of town. (Courtesy Lel Hawkins.)

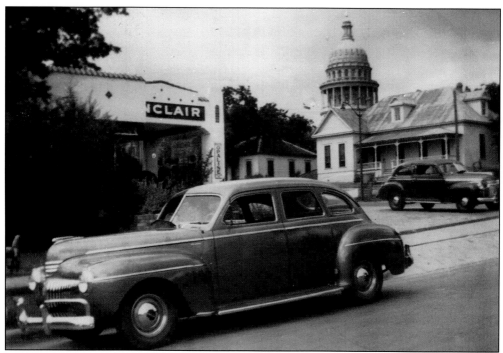

The capitol continues to dominate the skyline.

Two

Pioneer Families

The backbone of most communities is family, and Austin is no different. Dress and styles change, but the importance of family does not.

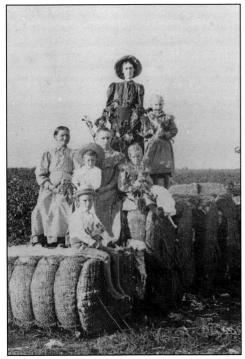

This was how the land looked in 1890, where the new Austin-Bergstrom International Airport is now located. This was prime farmland until the 1940s, when World War II began and Bergstom Air Base was built.

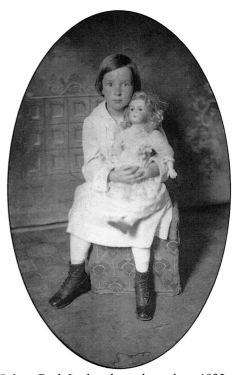

Celeste Ruth Luck is shown here about 1920.

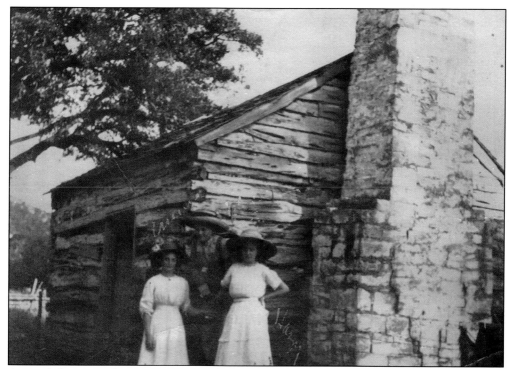

Austin ladies pose about 1916 at an early log home located on Bull Creek Road. This type of one-room log home with a limestone fireplace was common for early pioneer families in Texas. (Courtesy Cynthia Trenckmann.)

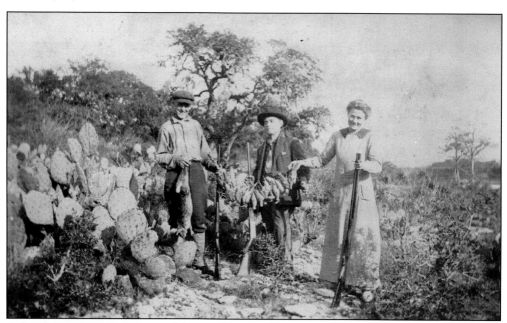

A family hunting trip, just out of the city limits at Onion Creek, proved to be bountiful. About 1910, the Jacobsen family (from left to right, Fred, F. A., and Hilmer) not only brought home a large number of birds but managed to add a rabbit to their kill.

Charlota "Lottie" Luna, left, was born in 1864 and married Toribio Fuentes about 1880. Here they are shown with their son, Frank Fuentes, who was born in Austin in 1881. (Courtesy Danny Camacho.)

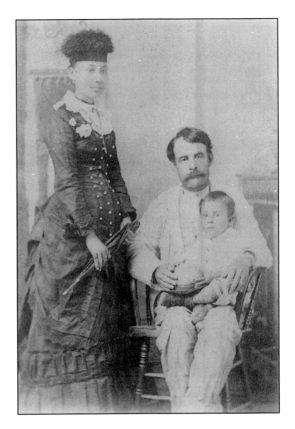

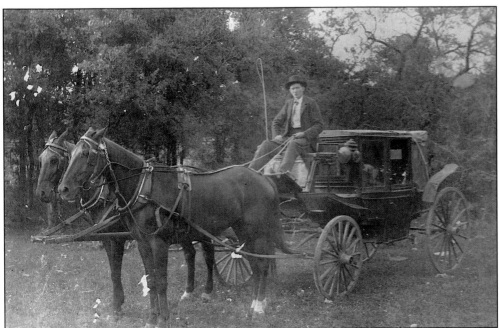

Austin families had many fancy carriages available to them. This type of carriage was also used for funerals.

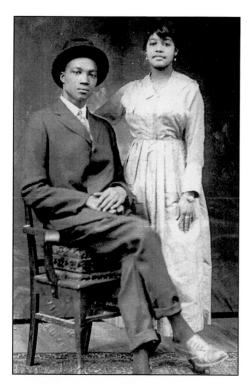

Walter Emery and Lottie Cabin are shown in 1913 about the time they married in Webberville, also known as Fort Prairie. Walter was born in Texas in 1890 and spent time working for the railroad and oil fields. Lottie grew up in a large farming family. (Courtesy Michael Emery.)

Frank Castro, shown here in 1915, was from one of the early Hispanic families in Austin. (Courtesy Danny Camacho.)

Helen Castro is also pictured in 1915. (Courtesy Danny Camacho.)

Pictured are Paul and Toby Castro in 1915. (Courtesy Danny Camacho.)

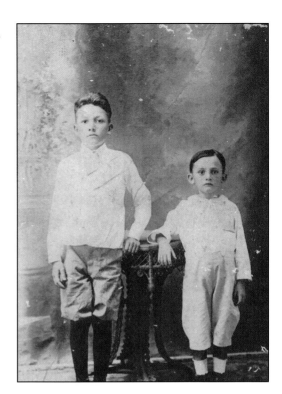

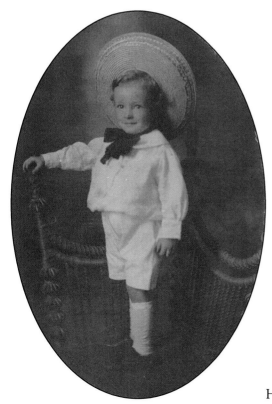

Here is Charles Luck in 1900.

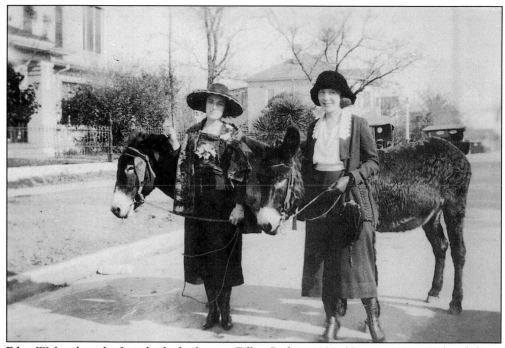

Edna Wukasch and a friend ride donkeys to Zilker Park in 1933. (Courtesy Ken Wukasch.)

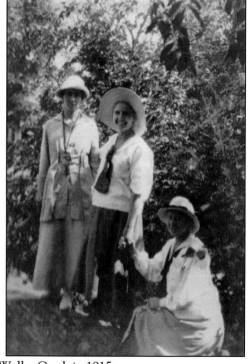

Austin ladies picnic at Waller Creek in 1915.

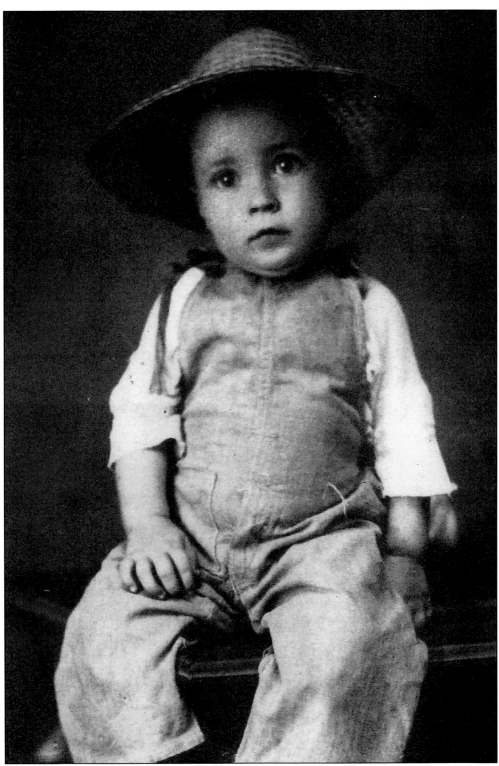

This 1912 photograph shows Earle J. Luck.

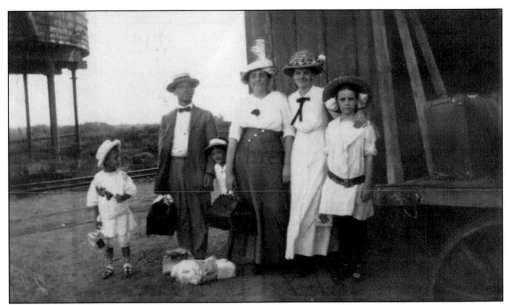

The Charles Wukasch family prepares for a trip. They are probably traveling to Serbin, Texas in Lee County where Charles was born in 1875. (Courtesy Ken Wukasch.)

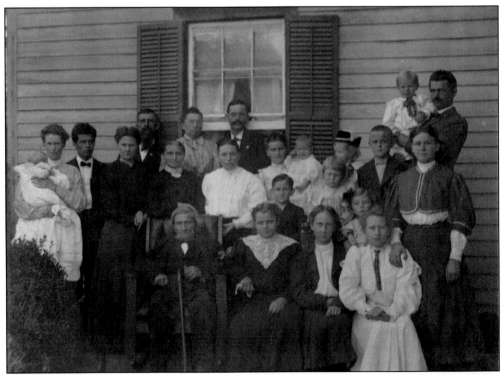

Peter Frederick Jacobsen, seated in the front row, was the patriarch of the Jacobsen family. He immigrated to Austin from Denmark in the mid-1800s. This photograph was taken in 1906 on Sabine Street.

Three

THE UNIVERSITY
OF TEXAS

The story of the University of Texas dates to 1832 when Stephen F. Austin suggested that schools and colleges be provided. On March 2, 1836 the Texas Declaration of Independence stated that Mexico "has failed to establish any public system of education, although possessed of almost boundless resources. . . and unless the people are educated and enlightened it is idle to expect the continuance of civil liberty, or the capacity for self-government." When Austin was laid out in 1839, 40 acres were designated as "college hill."

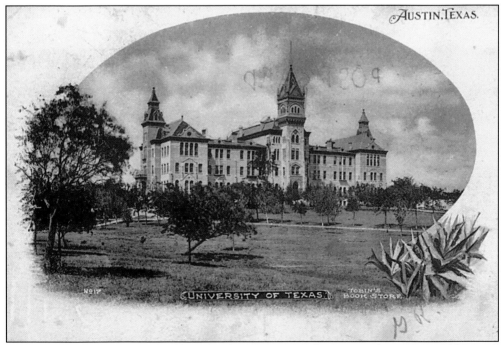

The original administration building for the University of Texas was known as "Old Main." (Courtesy Mary Hodge.)

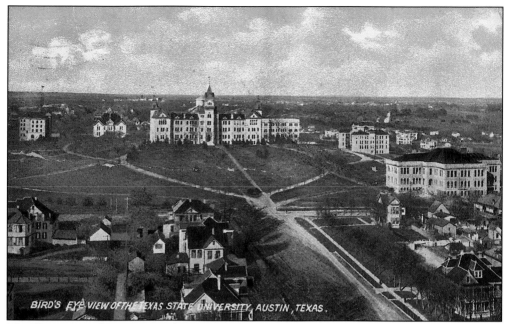

The University of Texas opened on September 15, 1883, with 13 professors and 218 students. Professors earned about $4,000. Several hundred trees were planted in 1884, and the Ex-Students Association was organized the next year. The opening of the university had a large impact on Austin, and continues to affect the city today. (Courtesy Ken Wukasch.)

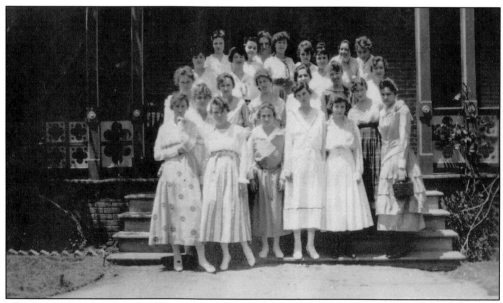

The ladies who lived at the University of Texas "Grace Hall" dormitory are pictured in 1916. (Courtesy Carl McQueary.)

The famous B Hall is pictured here in 1951. B Hall, completed about December 1, 1890, was built courtesy of George W. Brackenridge and his $10,000 donation. Students managed the hall where rooms were $6 a month, with two to a room, and board was $8 to $12 a month. Card playing and liquor were forbidden at B Hall. A glass of milk was 3¢, ham or steak was 3¢, hot biscuits 2¢, and soup or cake 2¢. (Photo by Jerry Hawkins.)

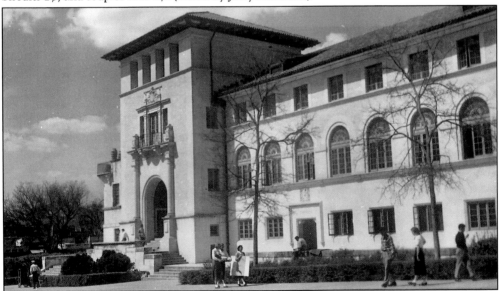

The Texas Union opened its doors in 1933. A massive fund-raising campaign conducted by the Ex-Students Association had provided the impetus as well as the funds for constructing the building. The building follows the Spanish Renaissance/Mediterranean revival style of architect Cass Gilbert of New York. (Courtesy Tom Rogers.)

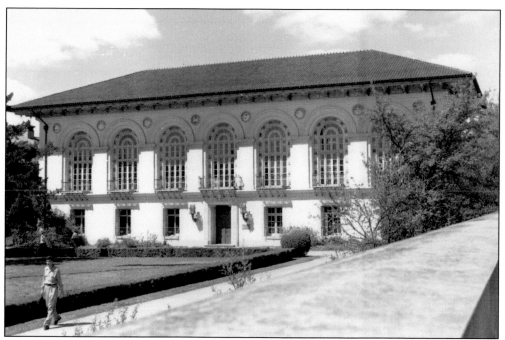

Considered by many to be the most beautiful building on campus, Battle Hall, designed by renowned architect Cass Gilbert, was built in 1910 as the first library. In 1930 it was renamed Battle Hall in honor of school president/professor Dr. William J. Battle. This building established the Spanish Renaissance style that would dominate the campus for many years. (Courtesy Tom Rogers.)

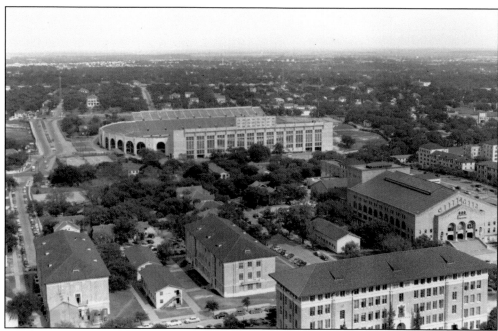

This is how Memorial Stadium looked in 1952. The stadium was dedicated on Thanksgiving Day, 1924.

The Texas Longhorn, "Bevo," is shown here on Thanksgiving Day, 1916 in Austin at Clark Field. (Courtesy Carl McQueary.)

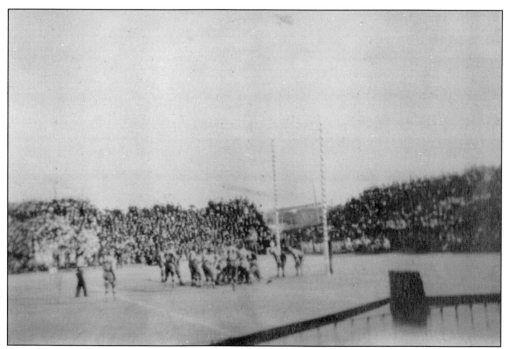

On Thanksgiving Day, 1916, the University of Texas defeated Texas A & M by a score of 21 to 7. As always, the stands were packed to capacity. (Courtesy Carl McQueary.)

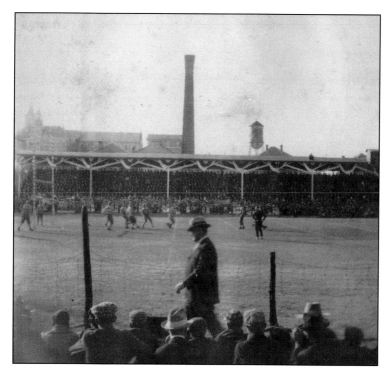

The Longhorns are shown leaving Clark Field at half-time. The athletic uniforms in 1916 were not much different from regular sporting clothes. (Courtesy Cynthia Trenckmann.)

The students and faculty march at the A & M game on Thanksgiving Day, 1916. The student in the foreground, wearing an orange and white beanie, is a freshman. This "beanie" custom is still practiced by members of the Longhorn Band. (Courtesy Cynthia Trenckmann.)

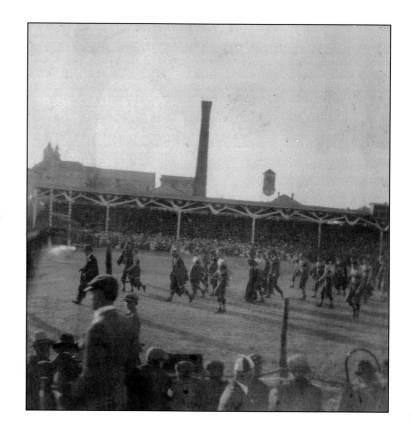

The Texas A & M students form a "T" and parade around the field in 1916. (Courtesy Cynthia Trenckmann.)

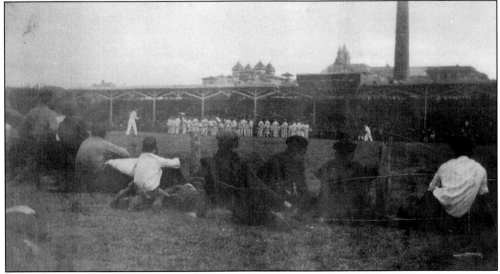

This 1916 photograph show how old Clark Field was always packed full for UT Longhorn games. (Courtesy Ken Wukasch.)

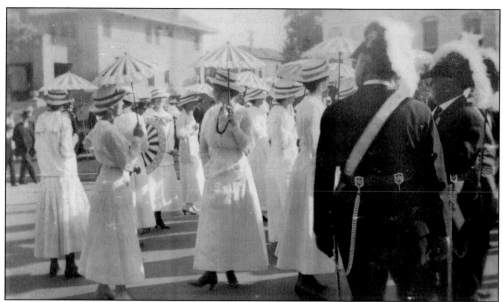

James E. Ferguson (1871–1944), from Bell County, attended Salado College at age 12, but was expelled for disobedience. He was elected Democratic governor in 1914 and reelected in 1916. In 1917, his veto of the University of Texas appropriations bill led to a major protest parade in Austin. (Courtesy Carl McQueary.)

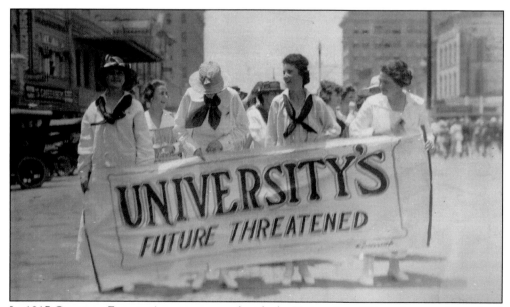

In 1917 Governor Ferguson's serious quarrel with the University of Texas began when school president Robert E. Vinson (1876–1945) would not remove regents and faculty upon Ferguson's demand. Students and faculty marched to protest the funds being cut, and dubbed the march the "Loyalty Parade." (Courtesy Carl McQueary.)

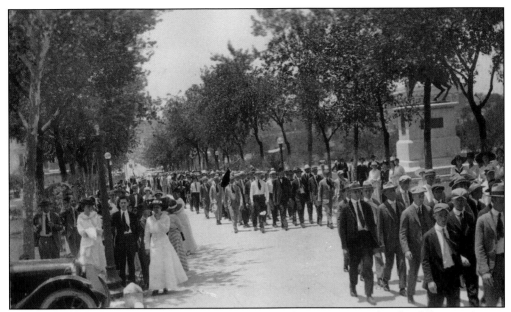

The entire faculty, staff, and students supported President Vinson, and realized Ferguson's veto of funds was in retaliation to the legislature that was being called into special session to consider impeachment of the governor. Indeed, in 1917, Ferguson was impeached and forbidden to hold public office again, and funding of UT was restored. (Courtesy Carl McQueary.)

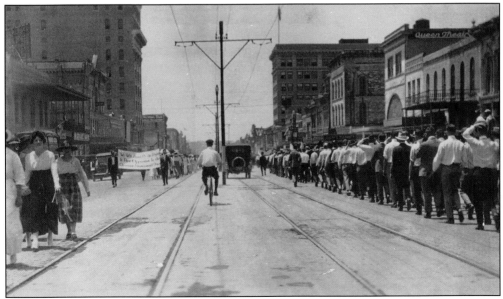

This 1917 UT parade was forgotten by 1924, when Jim Ferguson persuaded his wife, Miriam A. Wallace Ferguson (1875–1961), to run for governor against the Ku Klux Klan-backed candidate. "Ma" won, and was inaugurated governor 15 days after Wyoming's governor Nellie Ross was inaugurated, becoming the second woman governor in United States history. Billed as "two governors for the price of one," Ma was reelected in 1932. (Courtesy Carl McQueary.)

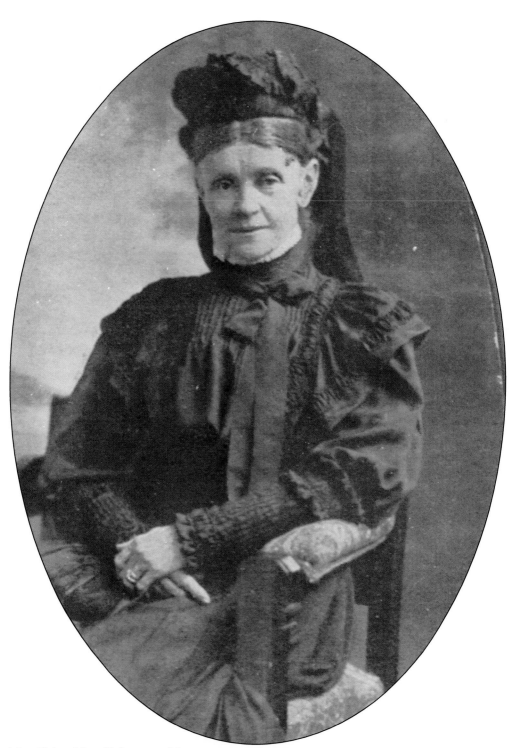

Mrs. Helen Marr Kirby started her career in education in Austin by opening the Alta Vista Institute on September 4, 1876. She went on to become the first dean of women at the University of Texas in 1889. (Courtesy Barker Texas History Center.)

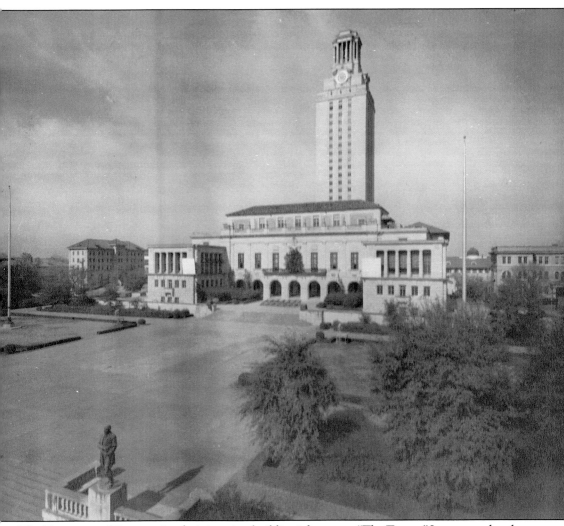

The University of Texas main administration building is known as "The Tower." It was completed in 1936 and continued the Spanish Renaissance style of architecture that was established by Cass Gilbert. Oil had been discovered on university land in west Texas in 1923, and became a funding source that greatly benefited the school. (Photo by Jerry Hawkins.)

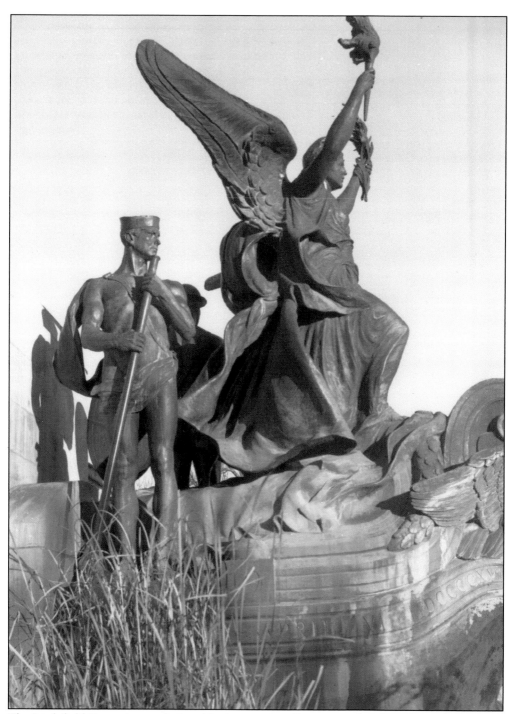

The Littlefield Fountain was designed by internationally renowned sculptor Pompeo Coppini. In 1932, the George Littlefield Estate gave $250,000 for the project and in 1935, the fountain was shipped from Italy to Galveston, where it was brought by train to Austin. Not only have many thousands of students ended up in the fountain; once, a 75-pound live alligator was removed as well.

The University of Texas Tower is especially important at night. After an athletic win or special achievement, the tower is lit in orange to recognize that event. If you missed hearing a game score, you can always tell if the Longhorns won by the tower's bright orange glow!

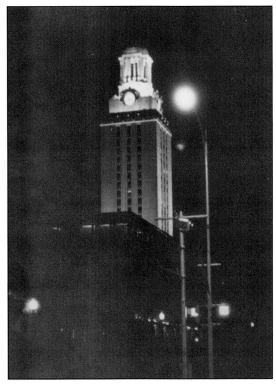

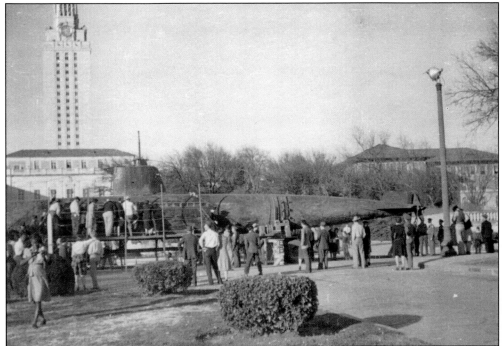

During World War II, a record number of UT students responded to the call for United States military service. In 1943, this Japanese submarine was on display on campus. (Courtesy Bee Crenshaw.)

"TU" was a popular name for the University of Texas after the turn of the 20th century. This 1916 parade was held to celebrate Texas Independence Day, March 2nd. It was on March 2, 1836 at Washington-on-the-Brazos, that the Texan pioneers declared independence from Mexico, which was gained seven weeks later at the Battle of San Jacinto on April 21, 1836.

This float was in another Texas Independence Day parade. (Courtesy Ken Wukasch.)

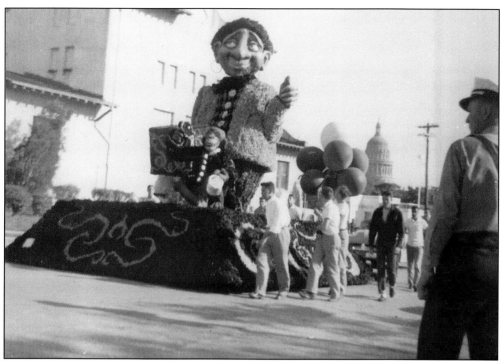

The Round Up Parade at UT was one of the most popular events held each year. This photograph dates to 1952. (Courtesy Tom Rogers.)

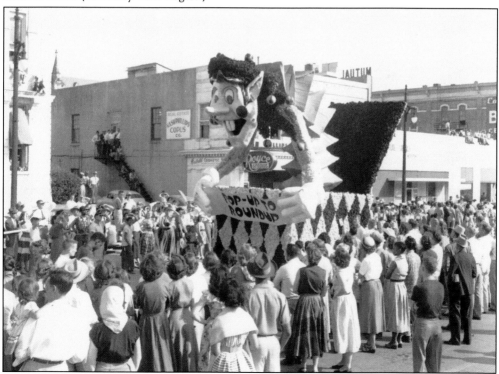

This photograph of the Round Up Parade is also from 1952. (Courtesy Tom Rogers.)

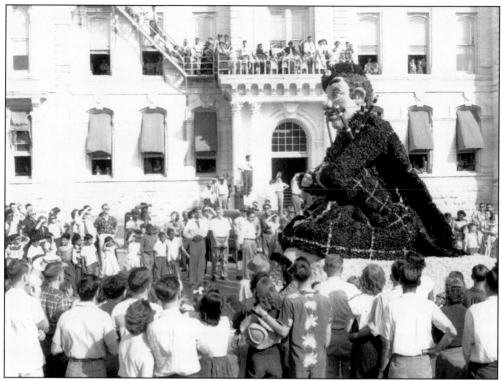

Another 1952 photograph shows the Round Up Parade. (Courtesy Tom Rogers.)

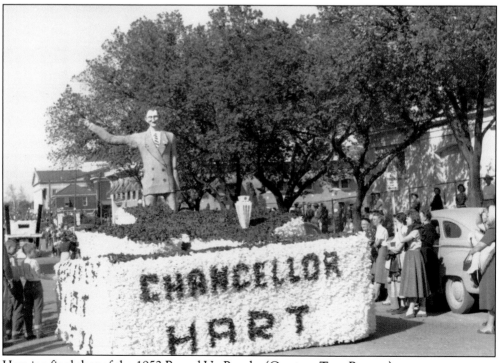

Here is a final shot of the 1952 Round Up Parade. (Courtesy Tom Rogers.)

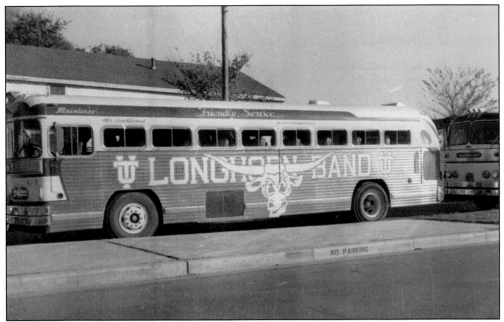

The University of Texas Longhorn Marching Band was organized in 1900 by Dr. Eugene P. Schoch. He purchased $180 worth of musical instruments from a pawnbroker, and managed to accumulate only 15 members. Dr. Schoch was an engineering professor and faculty member for 50 years. This bus was decorated *c*. 1952 for an out-of-town football trip. (Courtesy Tom Rogers.)

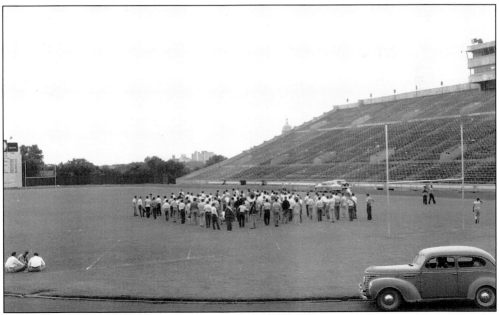

This 1952 Longhorn Marching Band practice was held at Memorial Stadium. Throughout the one hundred-year history of the band, a vast majority of the members have not been music majors, but students who like music and enjoy supporting the school, especially at football games. (Courtesy Tom Rogers.)

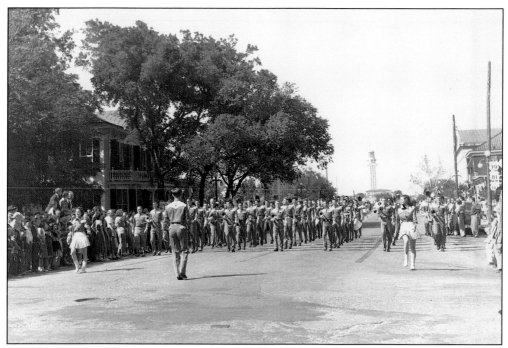

The Longhorn Marching Band is shown here in 1952. The drum major was Hal Atkins, and the majorettes are Sally Nichols (left) and Ann Arledge (right). (Courtesy Tom Rogers.)

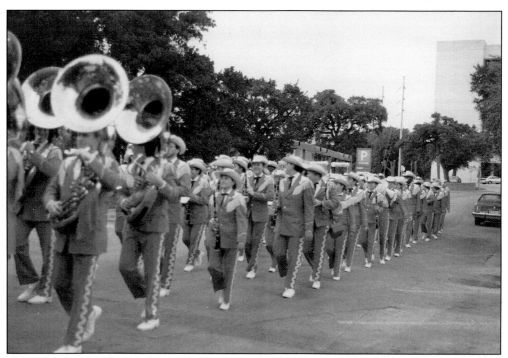

The "Showband of the Southwest" had grown to a 320-piece unit by 1988. In 1986, the band was awarded the Sudler Trophy for being the most outstanding university or college band program in the country.

The "Big Bertha" drum is one of the most recognized and popular parts of the Longhorn Marching Band.

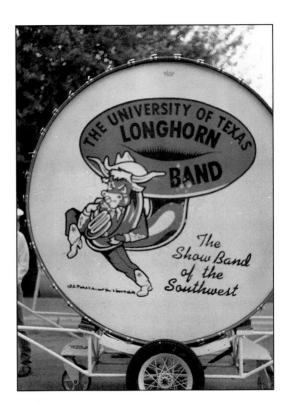

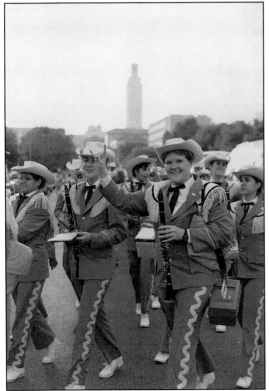

The Longhorn Band boasts an overall grade-point average of 3.3. More than 35% of the band's membership consists of those selected to Texas all-state bands and orchestras in high school, and another large percentage were valedictorians or salutatorians. Less than 10% of the band's membership actually comes from music majors; 65% major in business or engineering.

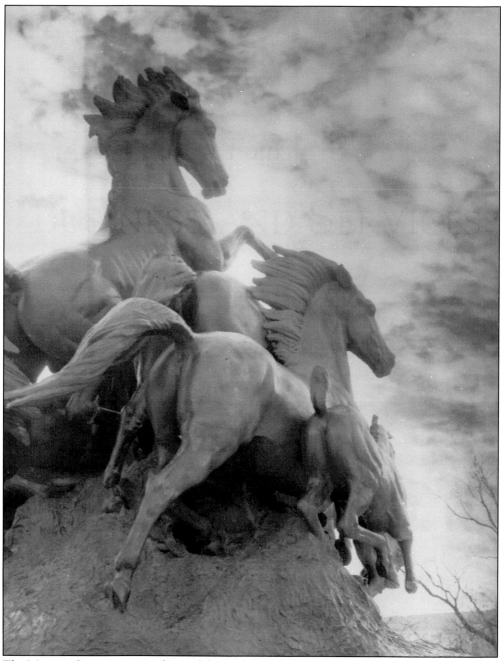

The *Mustangs* bronze statue in front of the Texas Memorial Museum on the UT campus was the idea of the late J. Frank Dobie. In 1939, Dobie was responsible for gathering the $60,000 in funds needed to get the project started. It was designed by A. Proctor and consists of one stallion, five mares, and one colt. The work was not finished until 1948. (Photo by Jerry Hawkins.)

Four

BUSINESS AND SERVICES

The economic development of Austin has come a long way since the time when goods were brought by wagon. The city is now one of the leading high-tech cities in America.

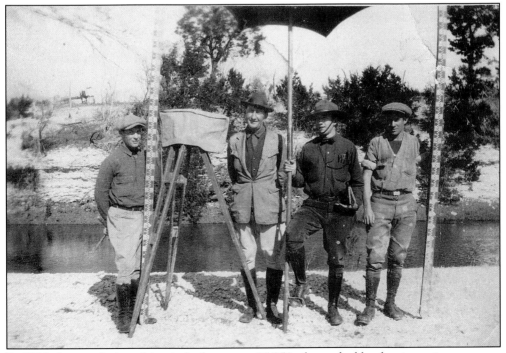

By 1900, the population of Austin had grown to 22,258, almost double what it was just ten years earlier in 1890. This survey crew is kept busy with such a growing city.

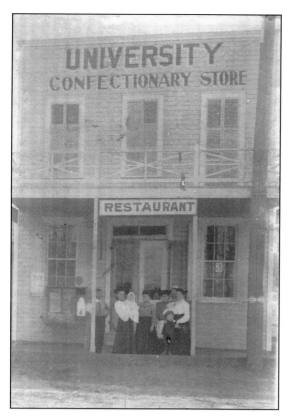

The University of Texas had an astounding enrollment of 986 students in 1900. Capitalizing on such a large population, Charles Wukasch opened his University Confectionery Store in 1902 at 24th and Guadalupe Streets. Charles had served as a private in the 1898 Spanish-American War and stayed in Austin following the war to search for work. His first job was at the Lundberg Bakery on Congress Avenue where he learned the skills to operate his own business. (Courtesy Ken Wukasch.)

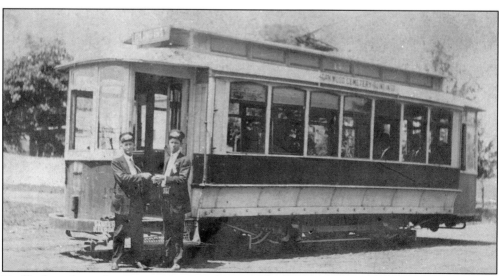

Traffic has always been a concern in Austin. This 1919 photograph of the trolley shows drivers Dan Tucker, left, and John F. Thompson, right. The route is the "Oakwood Cemetery-Blind Institute."

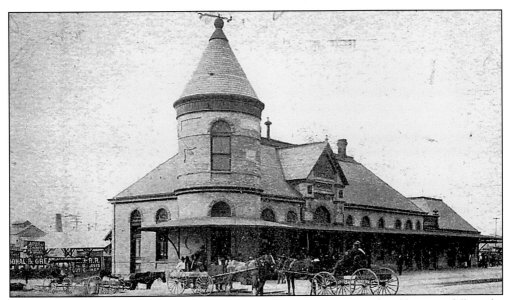

This railroad depot of the International and Great Northern was considered by many folks to be the most beautiful. The first train puffed into Austin on December 26, 1871 and bragged about "record runs" from Houston to Austin in "only" 17 and one-half hours. In 1875, 30,000 cedar trees were rafted down the Colorado River from the hills around Austin and shipped out via the railroad. By 1877, a "refrigerating beer car" was brought in also via the railroad. (Courtesy Mary Hodge.)

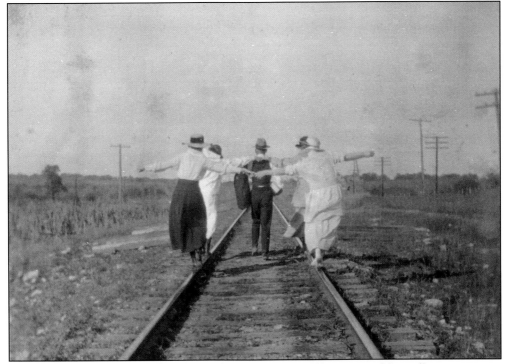

Use of the railroad tracks was not limited to the train. It often was used for walking excursions around town as in this 1915 photograph. (Courtesy Cynthia Trenckmann.)

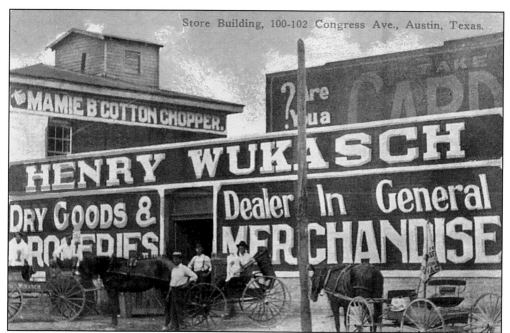

In 1904, Henry Wukasch opened this Dry Good and General Merchandise Store at 100 Congress Avenue. Henry believed in advertising, and it certainly paid off. By the time this photograph was taken in 1912, his business had certainly grown. (Courtesy Ken Wukasch.)

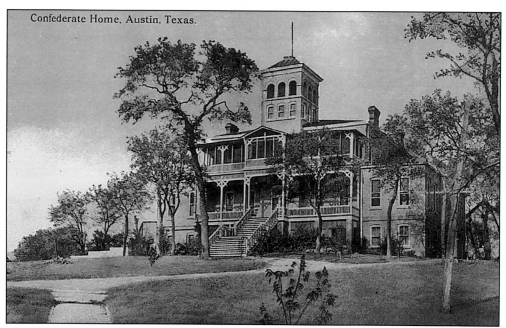

The Confederate Home in west Austin, on 6th Street past Deep Eddy, was established in 1886 as a project of the John B. Hood group of CSA veterans. The official dedication was not until March 13, 1887. In 1893, the operation was turned over to the state, and in 1891, 57 men were living at the home. The same year, it was noted that Kickapoo Indians were living in wigwams down below the depot. (Courtesy Mary Hodge.)

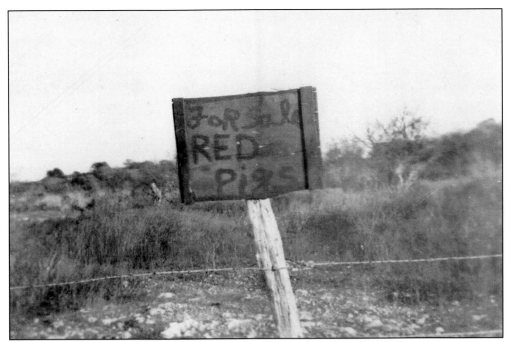

This sign was posted just outside the city limits in 1932. (Courtesy Ken Wukasch.)

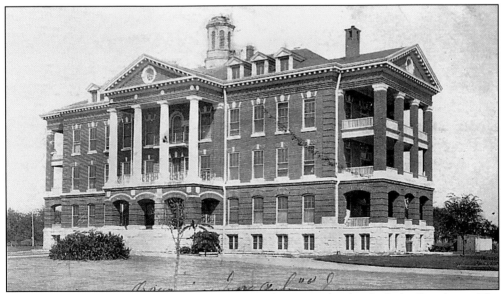

Seton Hospital was built after the turn of the 20th century by the Catholic Daughters. The building was torn down in the early 1970s. (Courtesy Mary Hodge.)

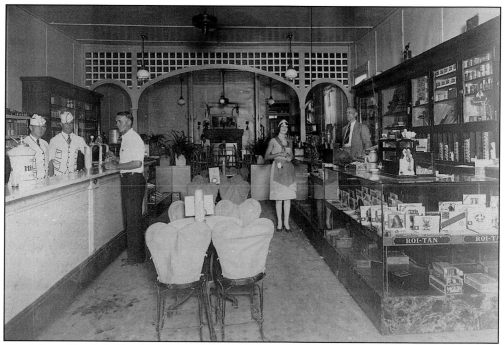

This is how Charlie's Confectionary Shop, at 2270 Guadalupe Street, looked c. 1925. Pictured, from left to right, are Carl White, Ed Boetcher, unknown customer, unknown waitress, and Mr. Charles G. Wukasch. (Courtesy Ken Wukasch.)

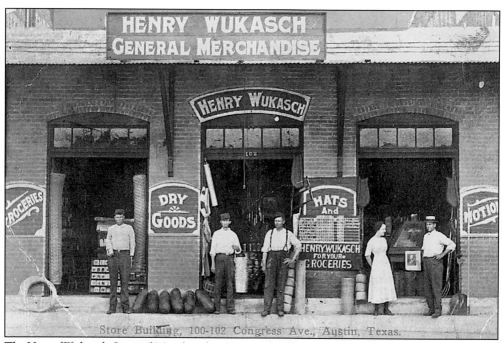

The Henry Wukasch General Merchandise Store, at 100–102 Congress, opened in 1904, remaining a major business in downtown Austin. It is shown here in 1937. (Courtesy Ken Wukasch.)

54

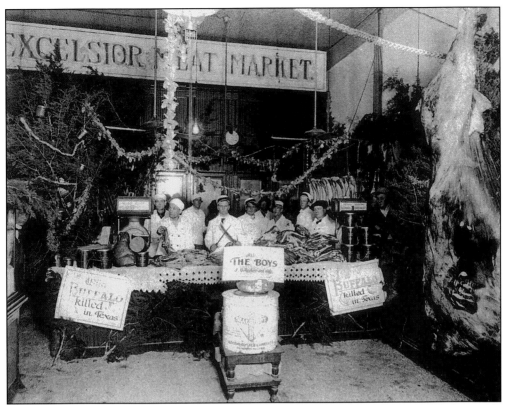

Charles Musgrove Robinson's meat market, Excelsior, was located at 308 West 5th Street. As shown in this 1900 photograph, they sold buffalo meat killed in Texas. (Courtesy Tom Flinn.)

The availability of automobiles in the early 1900s led to the increased use of business deliveries. (Courtesy Ken Wukasch.)

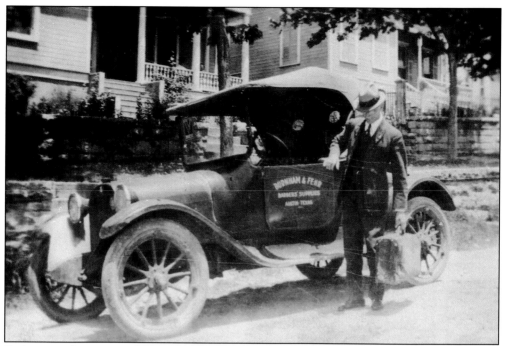

Barber supplies were delivered by this industrious businessman in 1933. (Courtesy Ken Wukasch.)

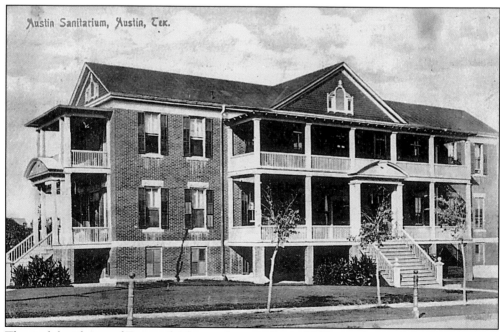

The sixth legislature of Texas, which went into session in 1856, appropriated the first funds and 400,000 acres for asylums in the state. A large portion, $50,000, was set aside to build a "lunatic asylum," or sanitarium. (Courtesy Mary Hodge.)

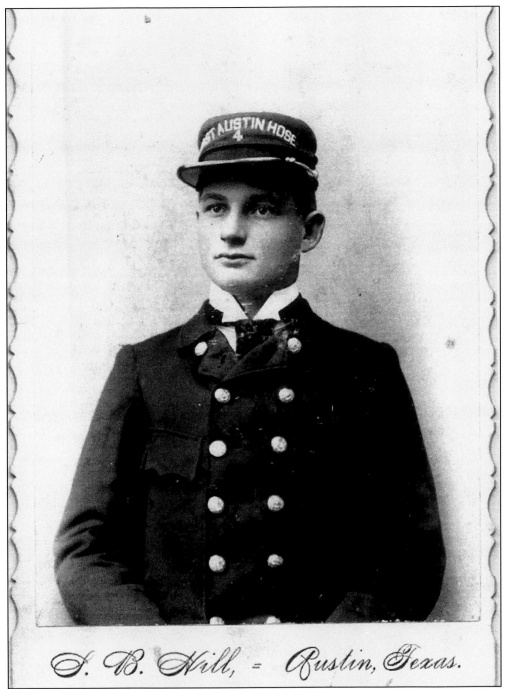

S. B. Hill, = Austin, Texas.

As soon as the city was founded, the need for fire protection became apparent. In November 1839, James Burke's public library burned to the ground, due to lack of a fire company. Innkeeper Richard Bullock started the first volunteer fire company in 1841. In 1858, John Bremond Sr. and William C. Walsh helped charter the Austin Hook and Ladder Company 1, and John T. Brown, a local blacksmith, built Austin's first fire truck. William McKenzie Bowden is shown in his fire company uniform in 1895. (Courtesy Tom Flinn.)

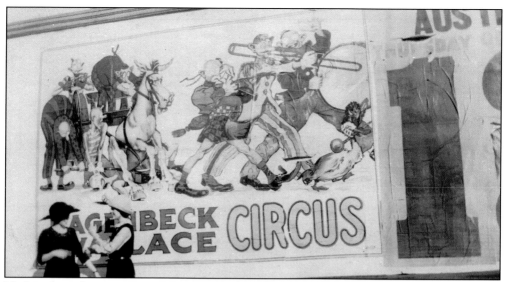

Nothing brought more excitement to town than the arrival of the circus. Usually a large circus arrived by train and marched the animals up Congress Avenue. (Courtesy Ken Wukasch.)

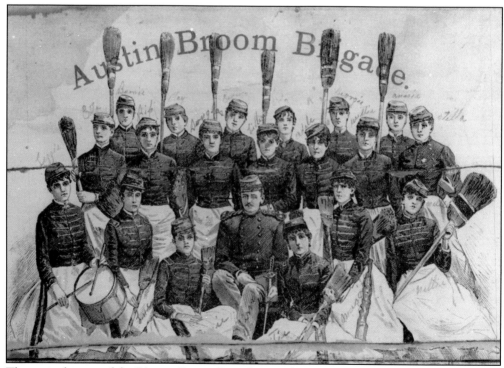

The entire history of the "Austin Broom Brigade" is unknown. It was more than likely a play or theatrical group, not smartly clad damsels, in military-like uniforms and carrying brooms, who actually cleaned streets or houses after a fire. (Courtesy Lel Hawkins.)

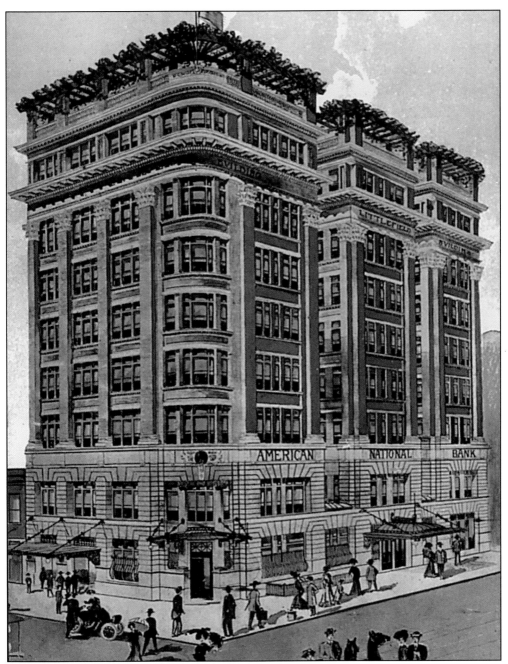

The Littlefield Building is considered by many to be the most beautiful building in Austin. It was built in 1910–1911 by Major George W. Littlefield (1842–1920), a cattleman and banker who served the Confederacy with Terry's Texas Rangers. The nine-story building on the corner of 6th and Congress has huge bronze doors depicting scenes from his ranches, and were cast by Tiffany Company of New York. In 1901 Littlefield purchased 312,000 acres of the XIT ranch for $2 an acre. He served as a University of Texas regent for many years, donated over $100,000 to purchase books for UT, left his home to UT, and for the first 50 years of the school's existence, was its largest benefactor. (Courtesy Mary Hodge.)

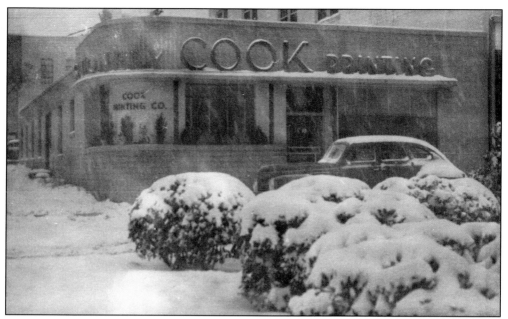

The Cook Printing Company operated for many years in Austin. It was a family operation, run mostly by brothers Frank and Sam and sister Mildred. Another sister, Katherine Cook, was a long- time educator for whom Cook Elementary School is named.

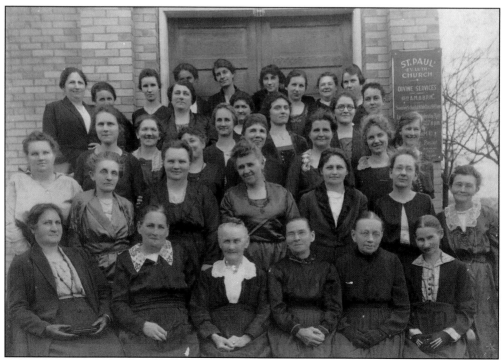

This was the Ladies Aid Society of St. Paul Lutheran Church. (Courtesy Ken Wukasch.)

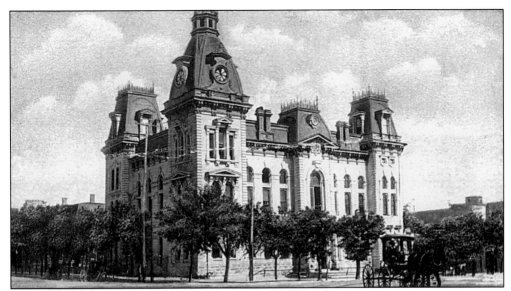

This was the third Travis County courthouse, built in 1876 at Eleventh and Congress. It was used until 1931 when the most current courthouse was built. (Courtesy Mary Hodge.)

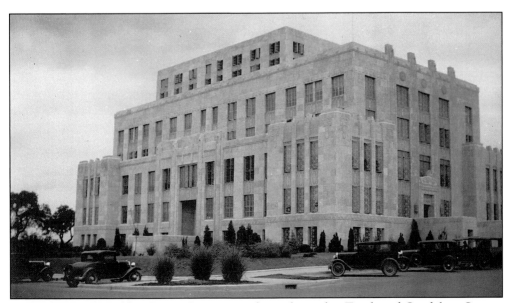

This is the fourth and last Travis County courthouse located at Tenth and Guadalupe Streets, built during 1931–1933. (Courtesy Ken Wukasch.)

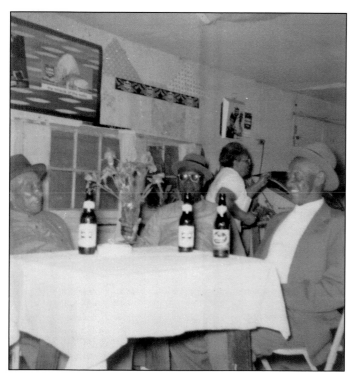

The "Gay Paree" cafe and tavern was located at 1711 East 12th Street. Owned and operated by Fannie Ussery Brown, it was the second-oldest beer tavern west of Chicon when it opened in 1946. Pictured, from left to right, are as follows: Jim Driver, a.k.a. "One Arm Driver;" Nathan "Buck" Yett (whose claim to fame was finding the body of murder victim "Madam" Tiny Barton in the 1950s); and World War I veteran Marcus Thompson. The only beer brands available after WW II were Southern Select, Grand Prize, and Falstaff. (Courtesy Ursula Carter.)

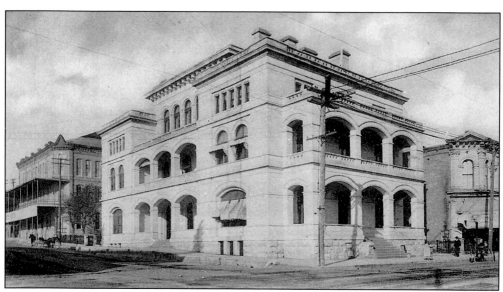

Austin had several post office buildings and William Rust, postmaster in 1857–1859, reported that he had four hundred private boxes for mail, renting at 50¢ quarterly. This new post office was built on the former site of the Carrollton Hotel about 1919. In 1901, free rural delivery had started in Travis County, and airmail began for Austin on February 6, 1928. (Courtesy Mary Hodge.)

Five

FUN AND ENTERTAINMENT

Recreation in Austin has largely centered around water. Clear and abundant, Barton Springs has been almost sacred since Billy Barton built his log cabin in the 1820s, and his "Waterloo" settlement became Austin in 1839.

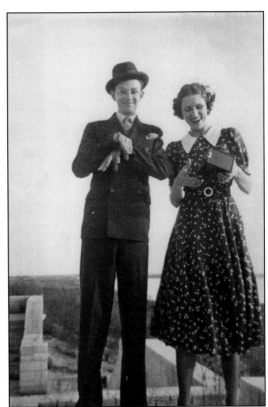

In 1888 George Eastman introduced the Kodak camera, which made photography available to millions of people. Eastman's slogan was "You press the button, we do the rest," and indeed, photography became an international hobby. This Austin couple is shown enjoying their box camera. (Courtesy Lel Hawkins.)

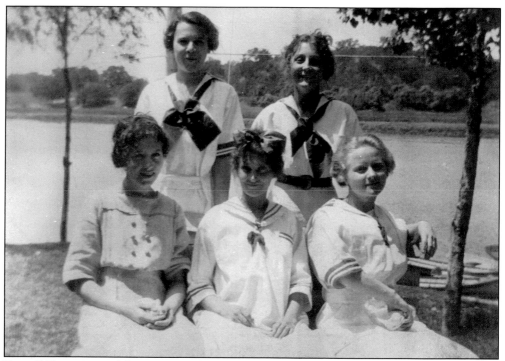

Deep Eddy was one of the most popular swimming and boating places in Austin. Located west of the Charles Johnson home (Johnson was a friend of Sam Houston), it was common for young ladies to spend the day there. (Courtesy Cynthia Trenckmann.)

In 1916 these young ladies spent the day at Deep Eddy. (Courtesy Cynthia Trenckmann.)

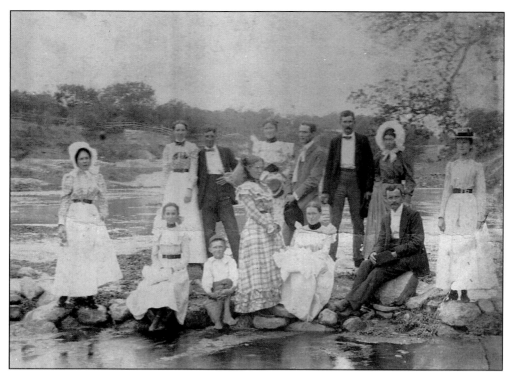

Barton Springs is one of Texas's finest natural treasures. Shown here in the 1890s, Charles P. Luck is seated in the front row at right, and Sophie Cook(e) Luck is next to him. Barton Springs is known as "The Soul of the City."

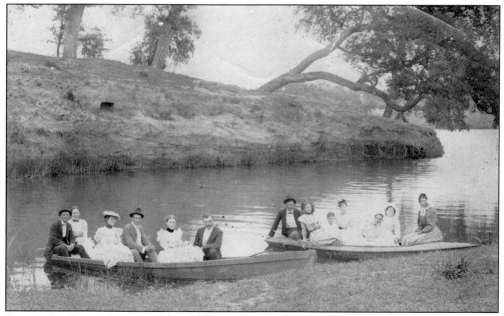

Barton Creek runs into the Colorado River, making boating another favorite activity. Barton Springs has a flow of 26 million gallons of cold spring water each day. When Austin was only known as "Waterloo," the three cabins that made up the settlement were here.

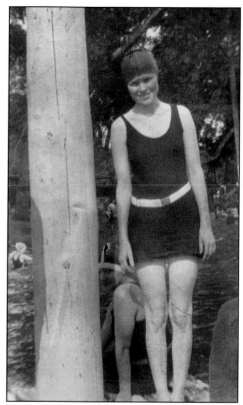

In 1932, these friends took an outing to Zilker Park. (Courtesy Ken Wukasch.)

Viola Luck sports the latest swimming attire in the 1920s.

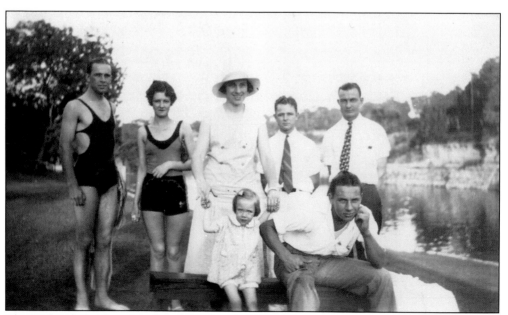

The Wukasch family enjoys Barton Springs in 1932. (Courtesy Ken Wukasch.)

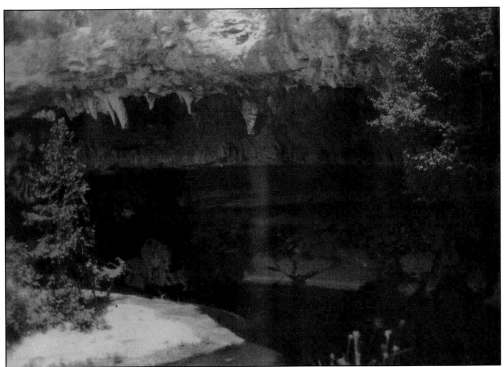

Hamilton Pool, located southwest of Austin in Travis County, is named in honor of Governor Andrew J. Hamilton (who served 1865–1866) who very much enjoyed an outing to this beautiful natural pool. From the waterfall, the pool is 95 feet down from the horseshoe-shaped bluff that overlooks the clear-blue spring water, as seen in this 1917 photograph. (Courtesy Cynthia Trenckmann.)

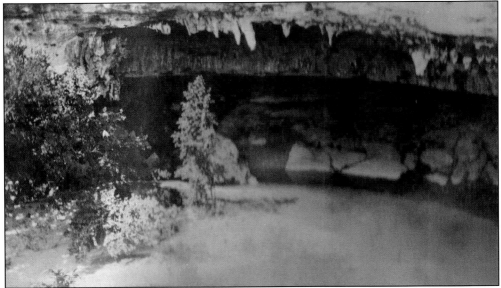

In traveling to Hamilton Pool, automobiles have replaced wagons, buggies, and surries, but this has always been a favorite place of seclusion and serenity. Native Americans used the area as a campground before the land was purchased in the 1840s. (Courtesy Cynthia Trenckmann.)

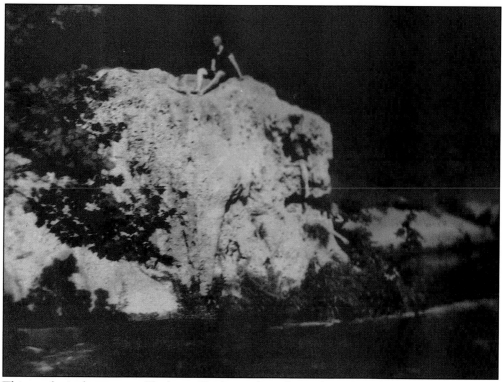

This rock is known as Elephant Rock, and is located at Hamilton Pool. (Courtesy Cynthia Trenckmann.)

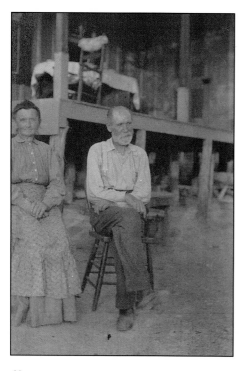

Longtime owners of Hamilton Pool were Mr. and Mrs. B.J. Reimers, shown here in September of 1917. (Courtesy Cynthia Trenckmann.)

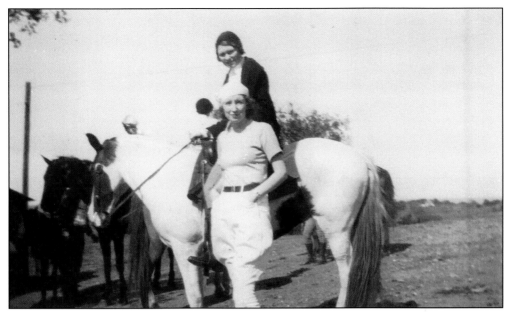

Sisters Viola and Celeste Luck were dressed for horseback riding in 1929 at a stable west of the city.

Although this photo is from 1917, goats are still a common sight in the Hill Country around Austin.

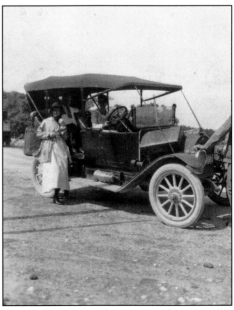

Automobile travel was a favorite for Sunday outings.

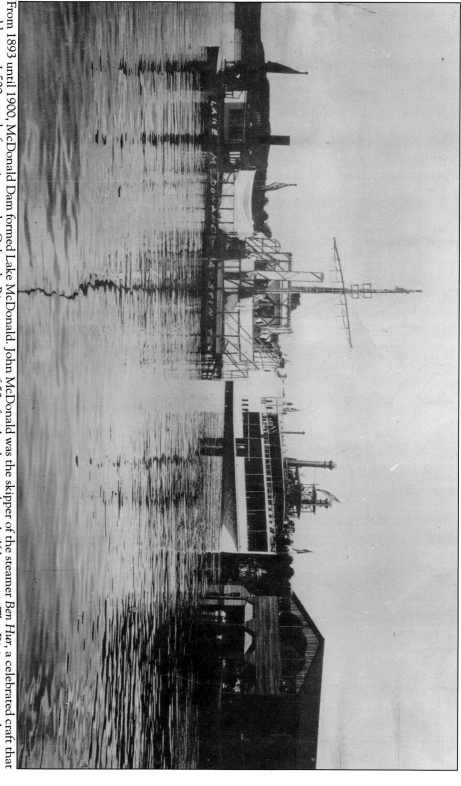

From 1893 until 1900, McDonald Dam formed Lake McDonald. John McDonald was the skipper of the steamer *Ben Hur*, a celebrated craft that could carry 1,500 people for cruises up the Colorado River, at a cost of 50¢ for the three and one half-hour trip. The *Dixie* steamer is shown to the left of the *Ben Hur*. (Courtesy Ken Wukasch.)

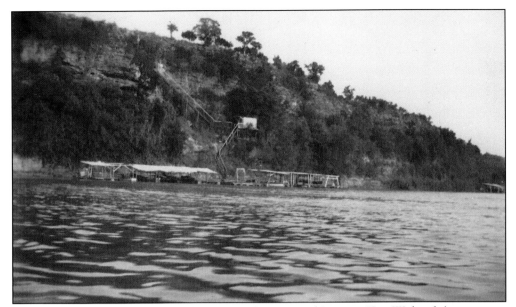

The original Austin Boat Club is shown on Lake Austin. (Courtesy Ken Wukasch.)

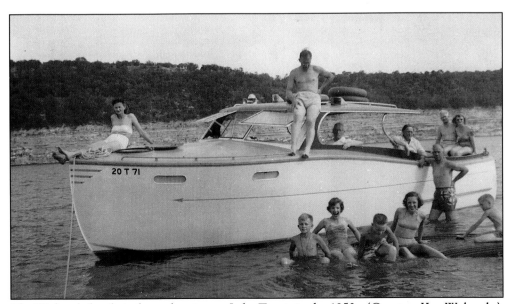

The Wukasch family is shown boating on Lake Travis in the 1950s. (Courtesy Ken Wukasch.)

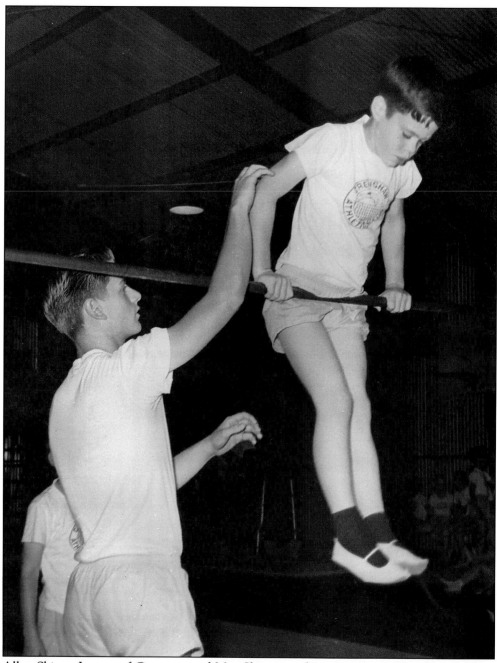

Allan Shivers Jr., son of Governor and Mrs. Shivers, took gymnastics at Crenshaw Athletic Club in 1952. Bee and Bill Crenshaw taught Austin children for almost 40 years. Bill was also a long-time gymnastics coach at the University of Texas. (Courtesy Bee Crenshaw.)

Six

HARD TIMES

Since Austin was laid out on the Colorado River, flooding has been a major concern. The Highland Lakes dam system was not established until the 1940s to control this sometimes deadly situation.

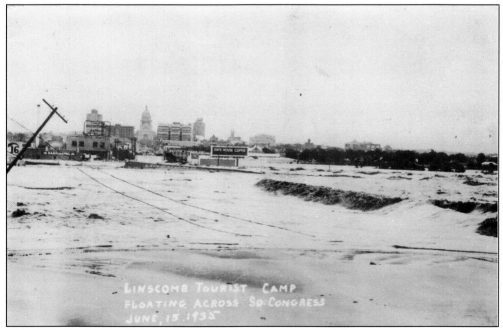

This 1935 flood of the Colorado River was the worst in Austin's history.

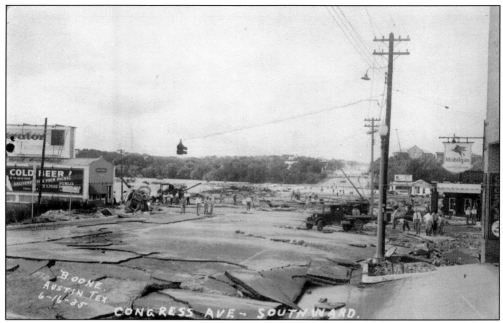

This view of the 1935 flood of the Colorado River looks south down Congress Avenue.

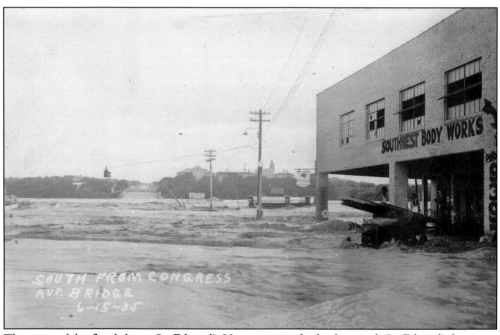

This view of the flood shows St. Edward's University in the background. St. Edward's began in 1872 when Father E. Sorin was in Austin from Notre Dame visiting the only Catholic church (now St. Mary's Cathedral). He purchased 123 acres south of Austin for a college. Mrs. Mary Doyle donated 398 acres. It took until 1885 to get a charter school started.

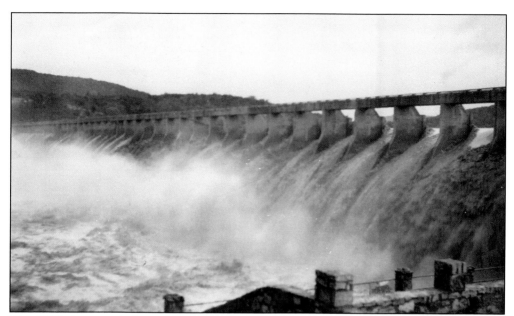

This 1935 photograph shows the floodwaters going over the dam. In the photograph below, the dam breaks. (Courtesy Ken Wukasch.)

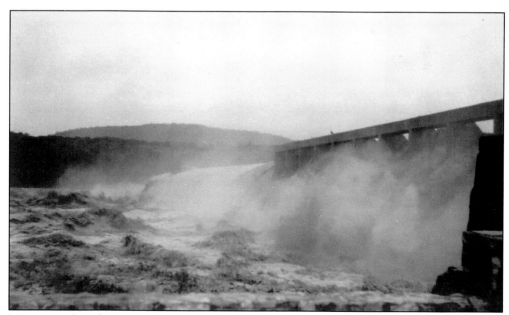

Moments after the top photograph was taken, the dam broke, flooding Austin. (Courtesy Ken Wukasch.)

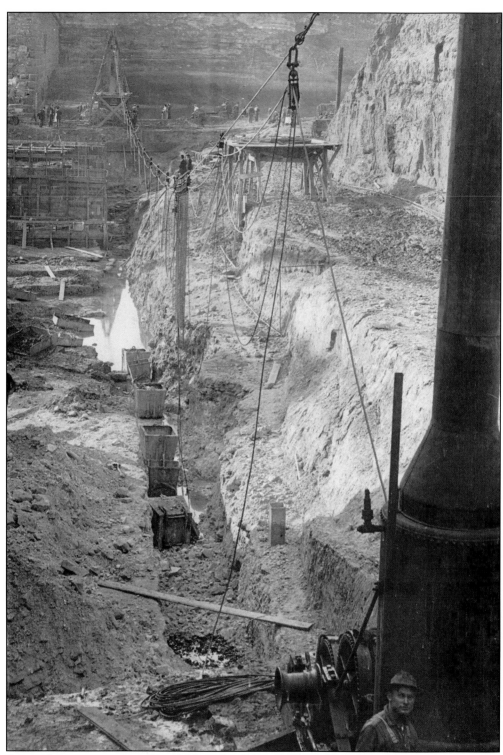

A new dam was constructed in 1914 on the Colorado River. Even this elaborate construction failed in 1935. (Courtesy Ken Wukasch.)

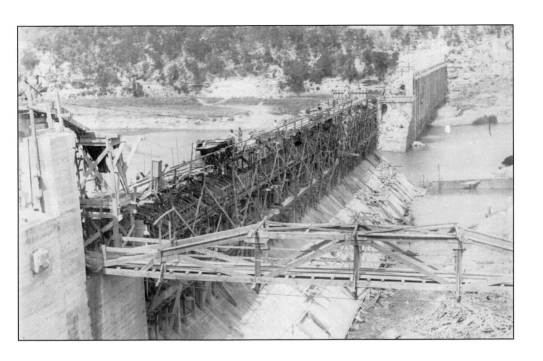

Here, construction continues on the new Colorado River dam. (Courtesy Ken Wukasch.)

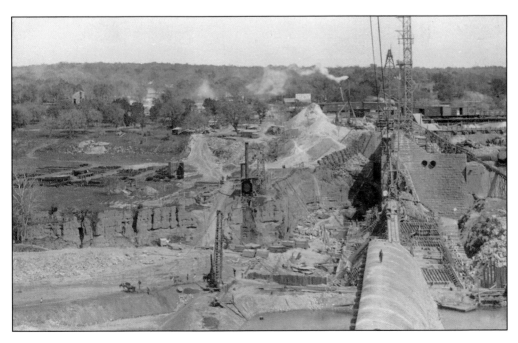

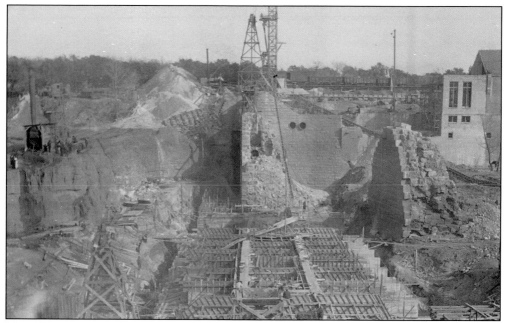

More dam construction.

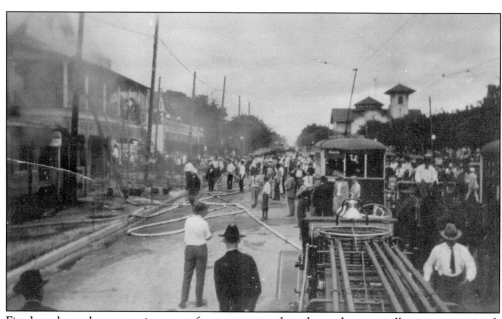

Fire has always been a major cause for concern, and as shown here, usually attracts a crowd. (Courtesy Ken Wukasch.)

Seven

CONGRESS AVENUE
AND DOWNTOWN

Austin and Washington D.C. are the only two capital cities originally designed specifically for that purpose. Edwin Waller was insightful in providing a wide Congress Avenue; the street has served the city well and defined "downtown."

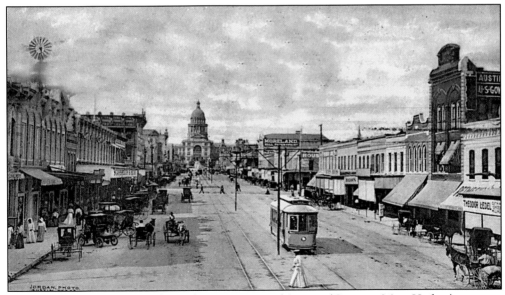

Congress Avenue has always been the main street of Austin. (Courtesy Mary Hodge.)

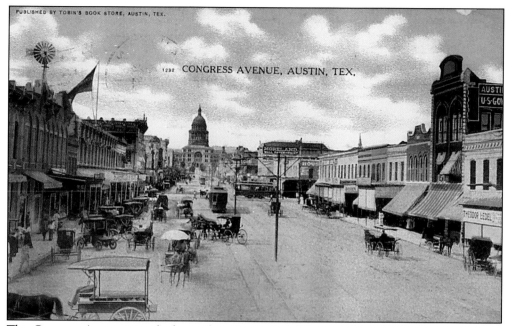

This Congress Avenue view looks north to the capitol. (Courtesy Mary Hodge.)

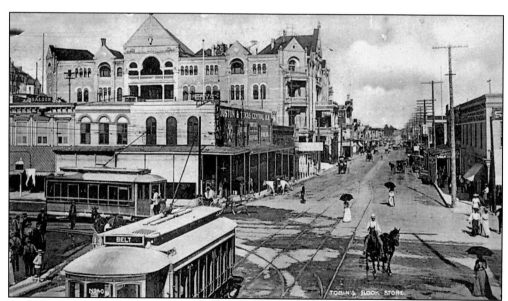

East 6th Street has always been the most commercial avenue, other than Congress Avenue. (Courtesy Mary Hodge.)

The letterhead for the Avenue Hotel.

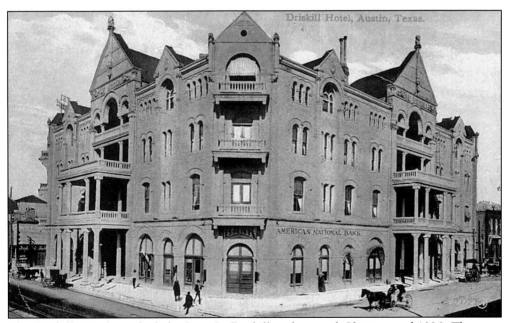

The Driskill Hotel was built by Jesse L. Driskill and opened Christmas of 1886. The cost, complete with furniture, was $400,000. The busts of Driskill sit atop the building on the south side, and his sons are depicted on the east and west sides and over the entrances. (Courtesy Mary Hodge.)

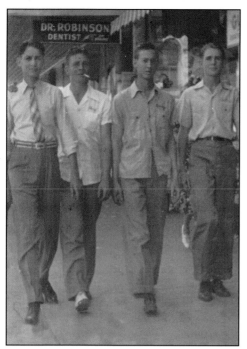

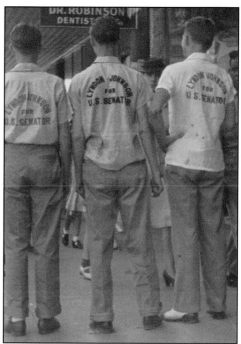

In 1941 Lyndon Baines Johnson ran for the U.S. Senate. He hired three high school students to campaign for him. Pictured, from left to right, are as follows: Wayne Connally (brother to future governor John B. Connally), and students Ikey Huffington, Vernon Dunlop, and George Taylor.

The three workers are shown wearing their special shirts on Congress Avenue just before the election. L.B.J. lost the 1941 race but went on to win many others. He became the 36th president of the United States on November 22, 1963, when President John F. Kennedy was assassinated in Dallas. (Courtesy Imogene Dunlop.)

E.M. Scarbrough advertisment calling itself "The 'Fashion Center' of Austin.".

An advertisement for John Bremond's Coffee.

An ad Mueller's Shoe Store.

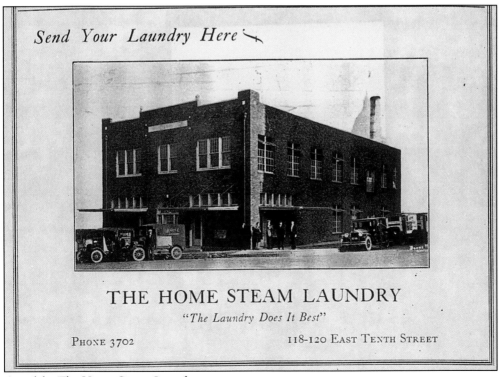

An ad for The Home Steam Laundry.

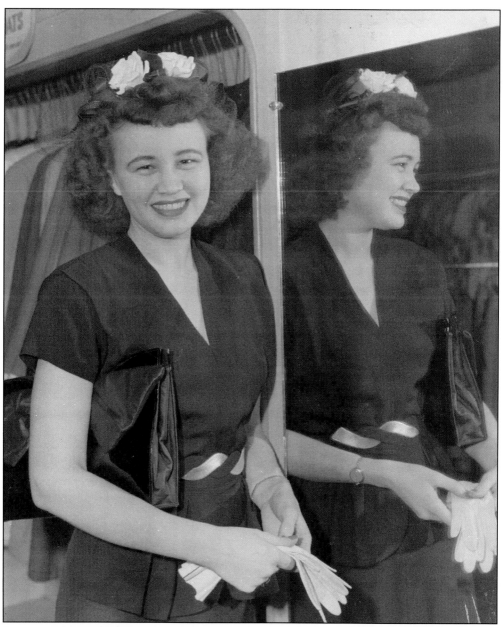

Frances McNeese Archer was a model at Scarbrough's Department Store during World War II. This 1945 photograph features a hat and gloves that were so stylish at that time. Scarbrough's was *the* department store in Austin until the late 1960s, when stores at "malls" were built. (Courtesy Frances Archer.)

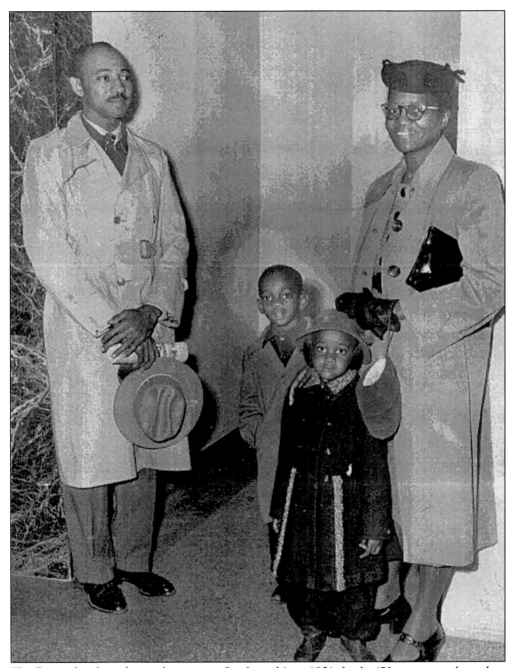

The Emery family is shown shopping at Scarbrough's in 1951. In the '50s everyone dressed up to go downtown. George Ellis Emery was a drafting teacher at the "old" L.C. Anderson High School located in east Austin. Olenka Davis Emery, a homemaker, is shown with children George Eugene and Yvonne Louise Emery. (Courtesy Michael Emery.)

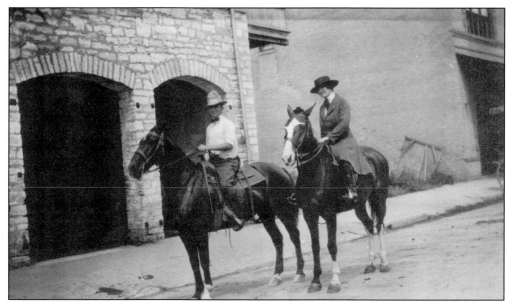

In 1917, Katherine Farley and her unidentified beau ride their polo ponies on Congress Avenue. (Courtesy Julia Whatley.)

Alfred Luck was one of Austin's early photographers, and is shown here in 1899. Alfred and his brother Charles operated a studio just off Congress, but they also traveled around Texas taking pictures.

In Austin, nearly everyone had their photograph taken on Congress Avenue. This is Charles P. and Sophie Luck in the 1930s.

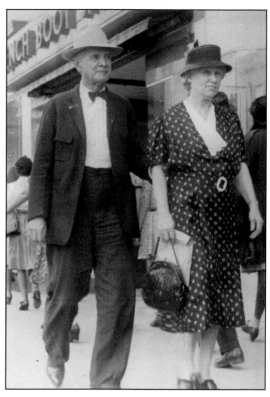

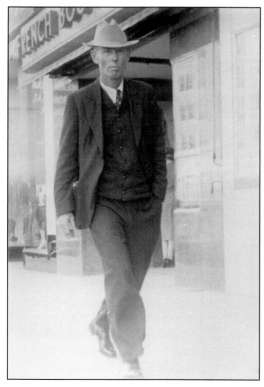

Ernest D. Mason, a rancher from Leander, is pictured on Congress Avenue in the 1930s. (Courtesy Christine Mason.)

This 1930s photograph shows Robert O. "Bob" Dannelly leaving his barbershop on Congress Avenue.

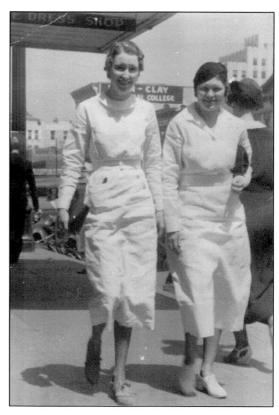

Sisters Celeste and Viola Luck are pictured going to lunch. Viola was a nurse for Dr. Will Watt, and Celeste was a dental assistant. She later worked at Bergstrom Air Base.

Frances Mason, left, and her Aunt Fannie Mason from Leander, spent the day shopping on Congress Avenue in 1940. (Courtesy Christine Mason.)

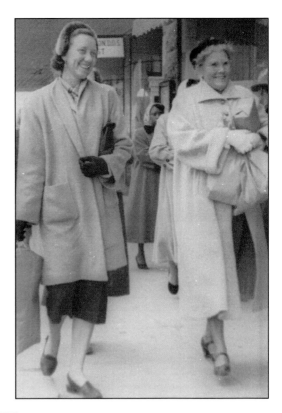

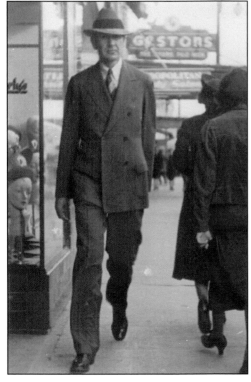

Dr. Will Watt was one of the most prominent physicians in Austin in 1940.

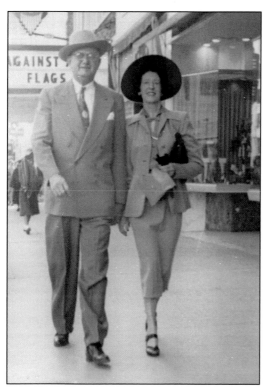

Stiles Byrom and his wife Katherine Farley Byrom of Georgetown are pictured here shopping in Austin. Byrom was the Williamson County District Clerk for 32 years. (Courtesy Julia Whatley.)

Webber and Mrs. McNeese came in from Merrelltown to shop in downtown Austin in this 1940s photograph. (Courtesy Frances Archer.)

Colleen Moore, left, and an unidentified friend are dressed for a parade down Congress Avenue in the 1930s.

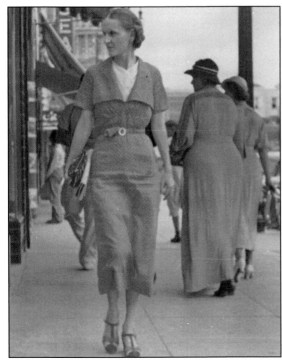

Mildred Cook is fashionably dressed for downtown shopping on Congress Avenue in the 1930s.

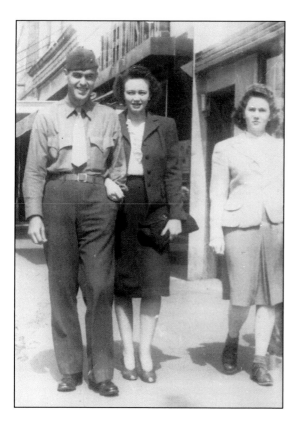

Eugene (left) and Frances Archer, and an unidentified lady, are shown near Scarbrough's in 1945. (Courtesy Frances Archer.)

This is the Austin skyline in 1940.

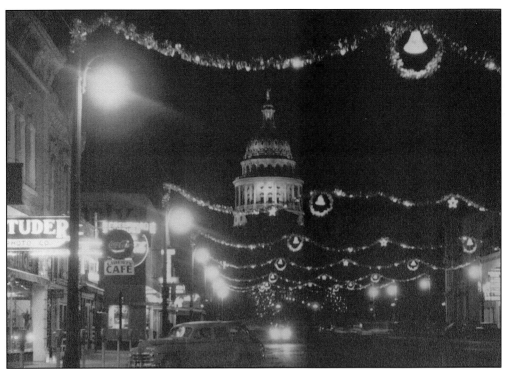

Here, Congress Avenue is decorated for Christmas in the 1950s. (Courtesy Lel Hawkins.)

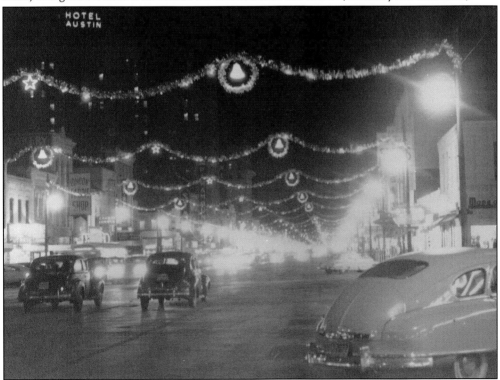

This view looks south to the river.

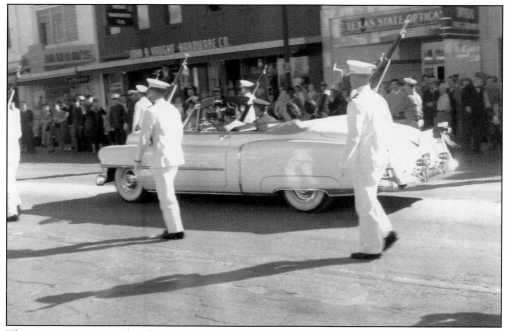

The inauguration parade of Governor and Mrs. Allan Shivers cruised down Congress Avenue on January 20, 1953. (Courtesy Tom Rogers.)

An ad for Patton's auto service.

Eight

HOMES OF AUSTIN

Log cabins and clapboard houses gave way to beautiful homes, suitable for the capital city.

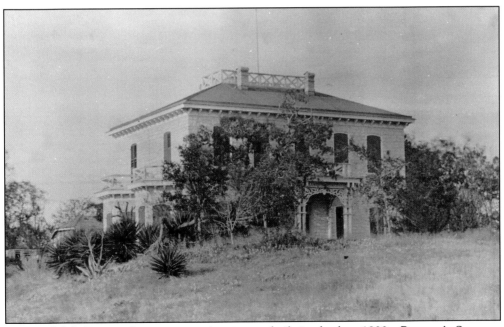

The Rudolph Bertram home in east Austin was built in the late 1800s. Bertram's Store, at 16th and Guadalupe, was the stage-stop for travelers heading north. The store wagon yard provided overnight "parking" for those out-of-town families, since the trip to Austin to go shopping took two days. This beautiful rock home is now a part of Rosewood Park. (Courtesy Cynthia Trenckmann.)

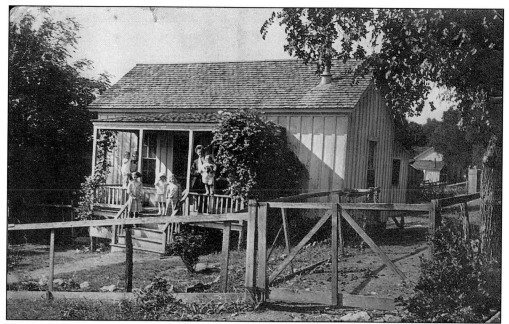

The 19th century home of Charles P. Luck was located at 11th Street and Baylor in west Austin.

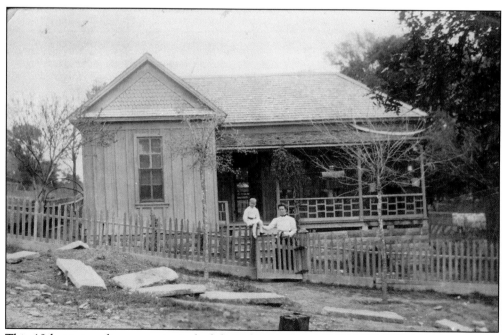

This 19th century home was typical of those houses being built in the hilly area of Austin, especially above Shoal Creek.

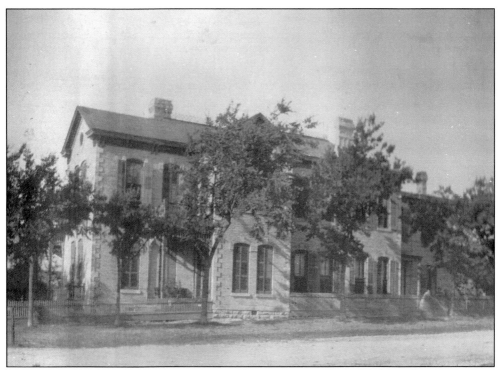

Francis R. Lubbock was lieutenant governor of Texas from 1857 until 1859, and governor from 1861 through 1863. When he left office, he put on the Confederate uniform and served as an aide to Jefferson Davis. His home was located at 1412 Congress Avenue. With two stories and long shuttered windows that opened onto balconies or porches, it was very typical of its time. Lubbock is buried in the state cemetery. (Courtesy Lel Hawkins.)

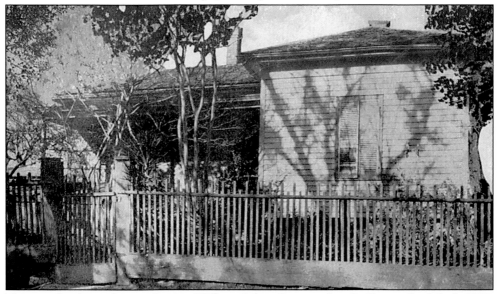

This was the Austin home of writer William Sidney Porter, a.k.a. O. Henry. On July 5, 1887, he married Athol Estes and did much of his writing in this house. The home is now a museum. (Courtesy Mary Hodge.)

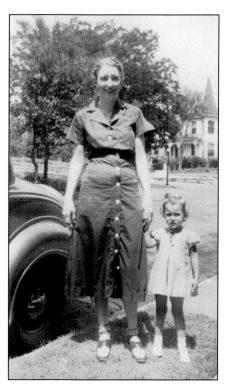

Celeste Ruth Luck, left, and a friend are pictured on West Avenue in the 1920s. The Caswell home is in the background. This is one of Austin's most beautifully restored homes. It was owned by D.H. Caswell, who came to Austin from Nashville. He was president of the Austin Oil Manufacturing Company, which started in 1891.

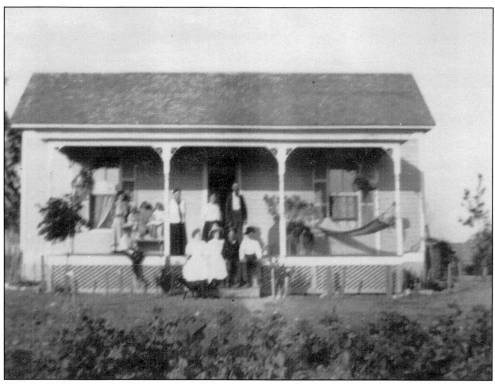

This is the Peterson farmhouse in rural Travis county.

Nine

FAMILY PETS
AND ACTIVITIES

Pets of Austinites were usually cats and dogs, but photographers often used goats.

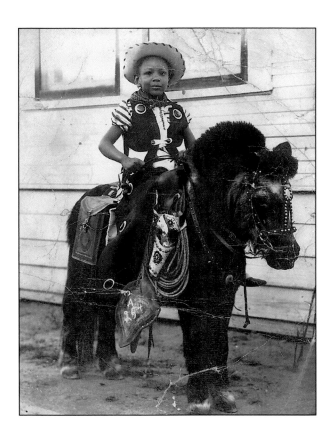

Ursula Brown (Carter) poses in 1949. What parent could refuse a traveling photographer complete with pony and cowgirl outfit? (Courtesy Ursula Carter.)

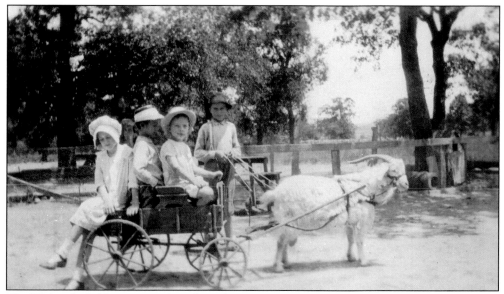

The Wukasch children enjoyed a ride in this goat cart in the 1920s. (Courtesy Ken Wukasch.)

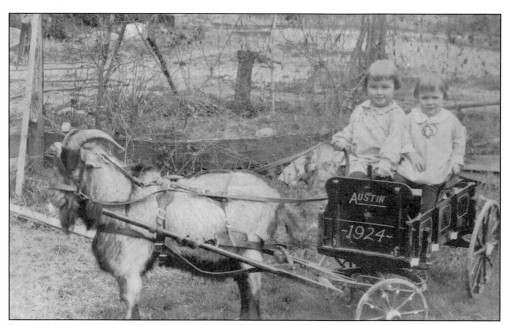

Bee and Doris Cain are shown in this 1924 photograph.

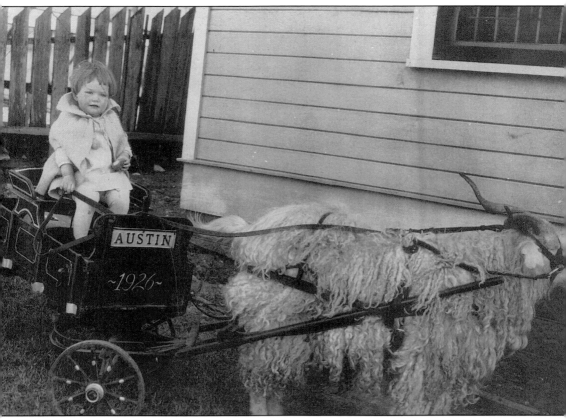

Tom Flinn posed for this photograph with Austin's most famous goat cart in 1926. (Courtesy Tom Flinn.)

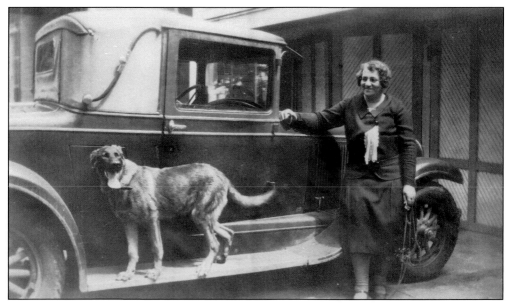

It is hard to tell whether this lady is more proud of her automobile or her dog! (Courtesy Ken Wukasch.)

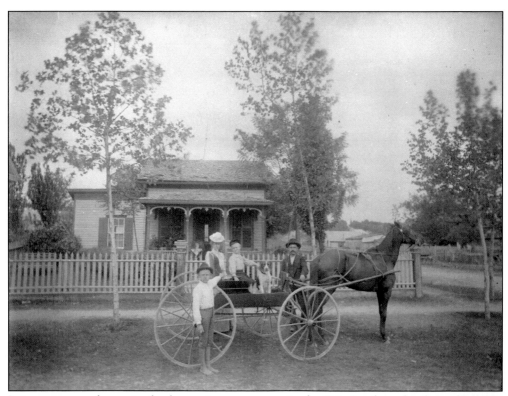

It is easy to see that animals play an important part in the F.A. Jacobsen family in this 1900 photograph. This home was located at 16th and Sabine Streets where the Erwin Special Events Center is now located.

Eighteen-year-old Celeste Ruth Luck, holding her cat, Michael, is boldly wearing pants in 1928! The 1920s were dramatic years for women. The passage of the 19th Amendment allowed women to vote and ushered in new-found freedoms, including fashions. Many Austin women worked tirelessly for women's suffrage, often marching in Washington, D.C.

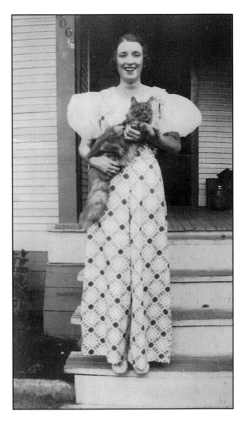

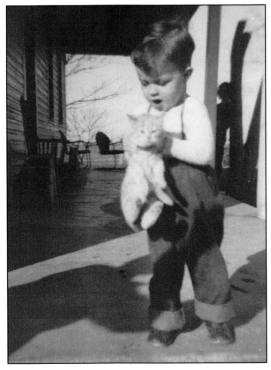

In 1952, four-year-old David Archer is holding a young yellow kitten at his grandparents' home in Merrelltown. David is the son of Eugene and Frances Archer. The kitten's mother was known as Puddy. (Courtesy Frances Archer.)

In about 1900, Charles Luck posed for his photographer father, C.P. Luck, in his Austin studio across the street from the Driskill Hotel.

In about 1946, young Ronnie Tobin had his picture taken on a pony.

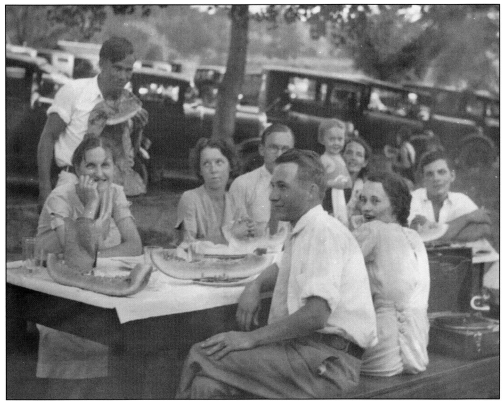

Family picnics have always been popular. This 1940 gathering in Zilker Park features watermelon.

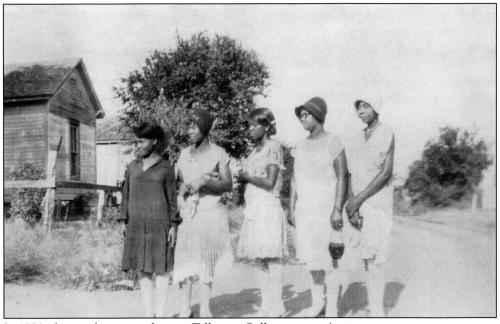

In 1930, these girls were students at Tillotson College in east Austin.

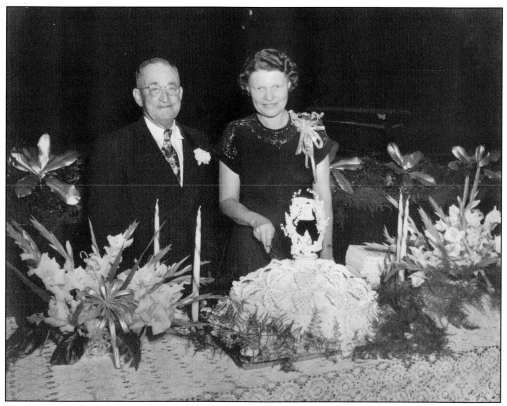

Frank and Viola Pinget celebrate their 25th "silver" wedding anniversary in 1949. Frank served in France in World War I.

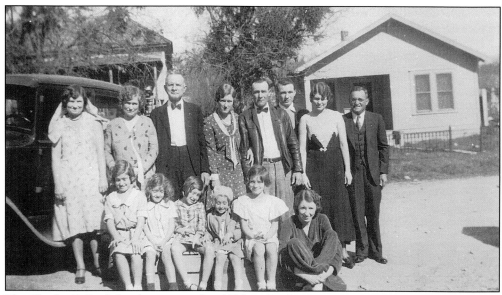

The Charles P. Luck family is pictured in 1930 on Baylor Street.

Ten

HONOR AND COUNTRY

Austin's men and women have often answered the call to arms in times of need. Honoring veterans has been an important event in the city.

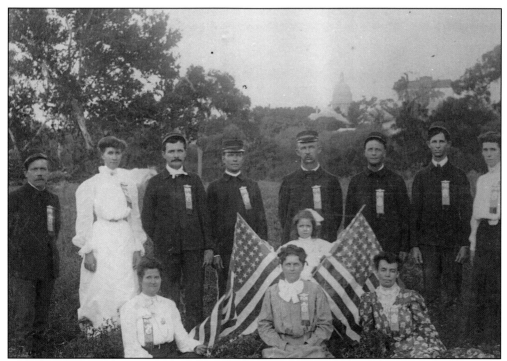

This photograph was taken about 1900 and is probably a July 4th celebration. Note the capitol in the background.

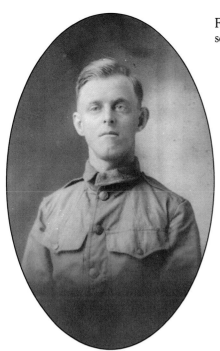

Fred Jacobsen was one of the many World War I soldiers from Austin.

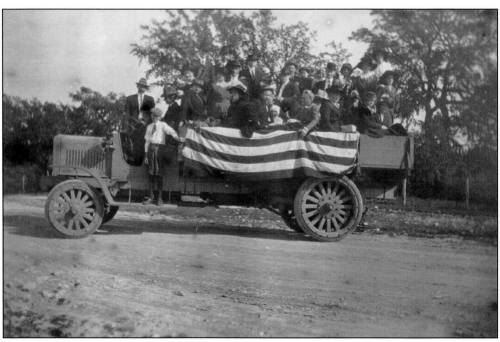

Patriotism ran high in World War I, and parades were a common way to show support for the United States troops far away in Europe.

W.A. "Bill" Crenshaw was in the Navy Coast Guard when he and Bee Cain married on July 15, 1941. The ceremony took place at her parents' home, 2102 Sharon Lane, in the new area of west Austin known as "Tarrytown." Bee and Bill went on to operate Crenshaw's Athletic Club and Camp for nearly 40 years. (Courtesy Bee Crenshaw.)

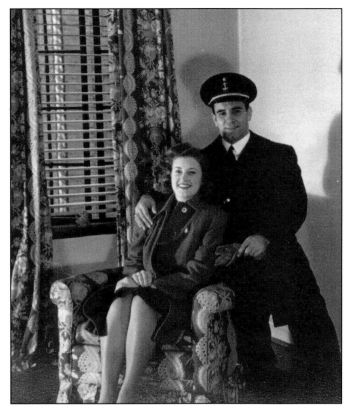

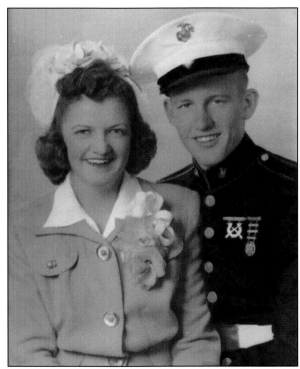

Arthur E. "Swede" Palmquist joined the United States Marines just after the Japanese bombed Pearl Harbor. When his girlfriend, Mary Helen Cain, visited him in San Diego, they decided to get married on June 19, 1943. Swede spent nearly four years in the Marines before returning home to Austin. (Courtesy Mr. and Mrs. A.E. Palmquist.)

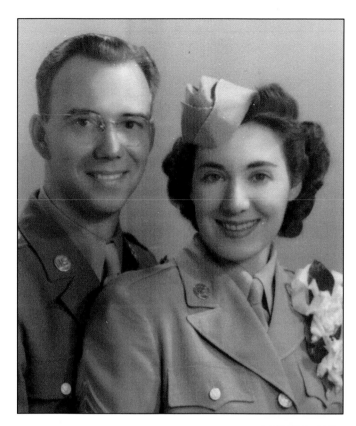

Army Air Corps Sergeant Forrest Scott of Austin was stationed at Geiger Field in Spokane, Washington during World War II. At Geiger, he met Irma Ruth Wilmes, a corporal, and they were married September 1, 1945. Forrest spent 4 and one-half years in the service, including 35 months in Bermuda. (Courtesy Forrest Scott.)

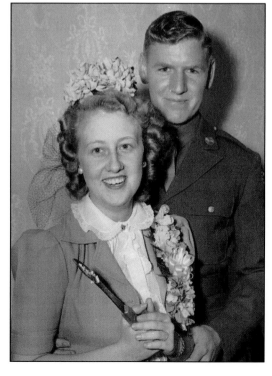

Dalton L. "Buddy" Tobin and Colleen Moore were married in Austin on April 2, 1943. Buddy had joined the army in 1942, and spent 21 months in Europe in the Army Air Troop Carrier Command. His son Ronnie was 18 months old before Buddy returned home to Austin to see him for the first time.

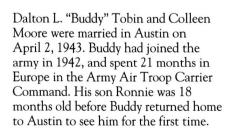

Chaplain Richard Lowe of Austin
served in World Wars I and II.
(Courtesy Ursula Carter.)

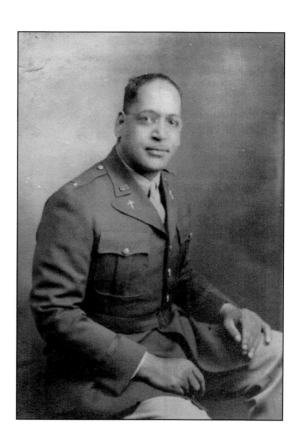

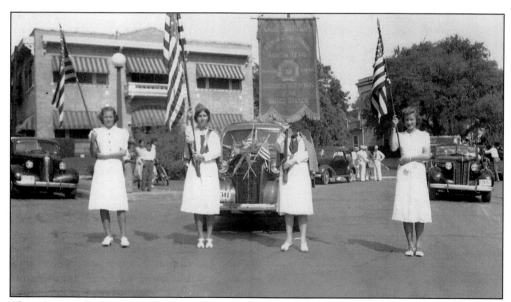

The Austin Ladies Auxiliary supported the United States Armed Services during a
1940s parade.

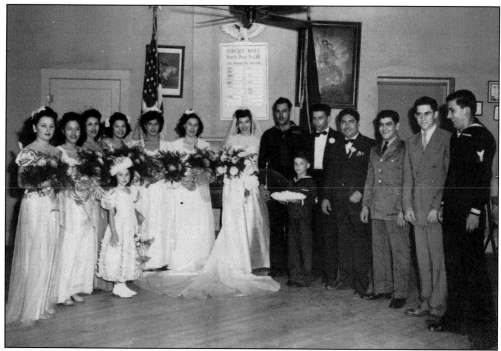

On August 29, 1944, Santos Acosta married Toby Fuentes at the American Legion, Travis Post #76. Pictured, from left to right, are: Nora Lozano, Lona Onn, Pauline Sanchez, Sandy Ruiz, Elodia Rivera, Eloisa Cruz, the bride Santos, groom Toby, Tony Cruz, Basilio Rivera, Sam Casarez, Hector Lopez, and Fernando Benvaides. The flower girl was Miss Rios and the ring bearer, Master Ledesma. (Courtesy Danny Camacho.)

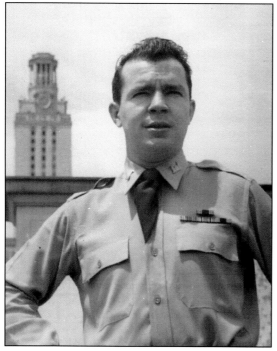

Lieutenant William R. Rollins, of Sydney, Texas, received his commission in the Corps of Engineers in May 1950 through the ROTC program at the University of Texas. This photograph was taken in front of the Littlefield Fountain. Within a year or two, Bill was killed in Korea. (Photograph by Thomas R. Rogers.)

Eleven

EDUCATION AND
CIVIC DEVELOPMENT

Education has been a cornerstone in Austin from the beginning. Early school classes were often held in churches, but proper facilities were soon built.

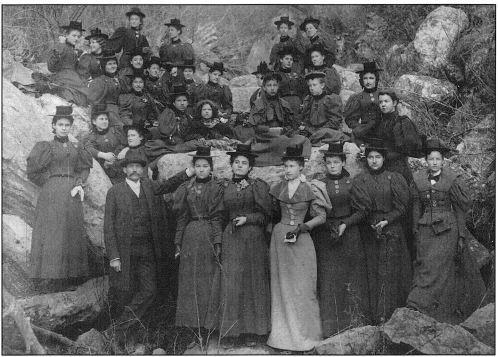

The Stuart Female Seminary Class gathered on the river bank before an excursion to Lake McDonald on the *Ben Hur* in 1895. Pictured, from left to right, are as follows: (front row) seminary president Rev. John M Purcell, Blanche Mason, Tina Busby, teacher Miss Beatrice Graves, May Barnes, Bessie Bull, and Miss Pattie Guthrie, teacher. The facility opened in 1882 at the corner of East 9th and Navasota Streets and was in operation until 1900. (Courtesy Lel Hawkins.)

Mary Frances Blake was born in Mississippi in 1837 and moved to Houston in 1846 just as the Republic of Texas had become a state. At the age of 12 she went to the Hartford Female Seminary in Hartford, Connecticut, and in 1859 returned to Texas to teach. She married Robert C. Stuart II and came to Austin to teach at the Stuart Female Seminary. (Courtesy Lel Hawkins.)

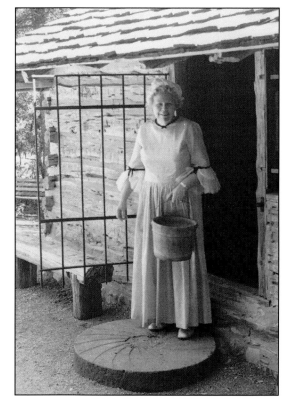

Mrs. Martha Ingerson is working at the restored Esperanza School. The one-room log school was originally located west of Austin on Bull Creek Road but is now at the Austin Area Garden Center at Zilker Park. (Courtesy Lel Hawkins.)

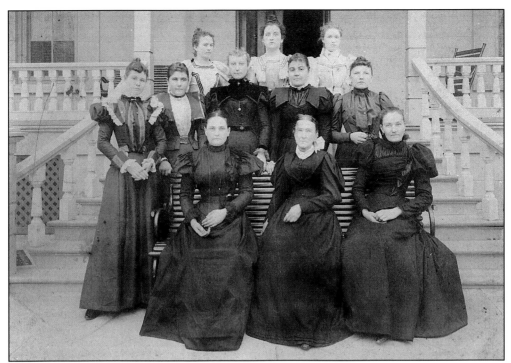

This school was built as the "Blind Institute" in the late 1850s. Provisions of $10,000 were set aside for this facility to serve the blind. Dr. S.W. Baker was superintendent, and the board of trustees consisted of J. Caldwell, George Paschal, J.W. Phillips, R.J. Townes, and S.M. Swenson. This was the staff in the late 1890s.

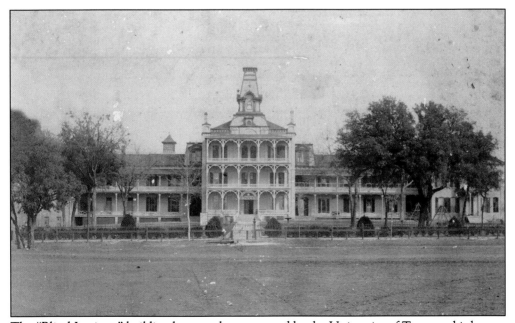

The "Blind Institute" building has now been restored by the University of Texas and is known as "The Little Campus."

Miss Emily Lewis was the first girl to attend the Texas School for the Deaf, and became the first female teacher there. (Courtesy Texas School for the Deaf.)

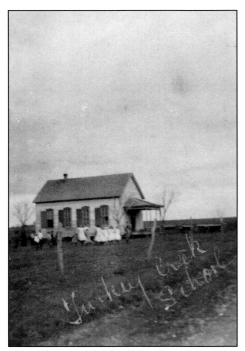

The Turkey Creek School was in the country northeast of Austin. This is how the one-room school looked in 1911. (Courtesy Cynthia Trenckmann.)

In 1911, lady teachers were required to be single, but boyfriends could attend the Mayfest activities. (Courtesy Cynthia Trenckmann.)

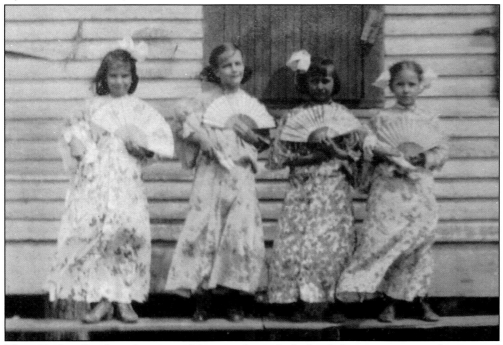

These Turkey Creek students are celebrating the end-of-school closing program in the spring of 1912. (Courtesy Cynthia Trenckmann.)

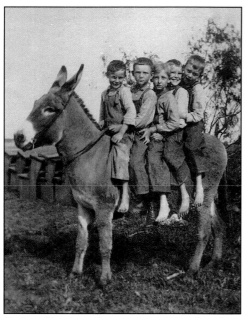

Turkey Creek students enjoy riding this donkey, which didn't seem to mind 5 kids at one time! (Courtesy Cynthia Trenckmann.)

These boys are holding cans of paint and paintbrushes, apparently to paint the school. (Courtesy Cynthia Trenckmann.)

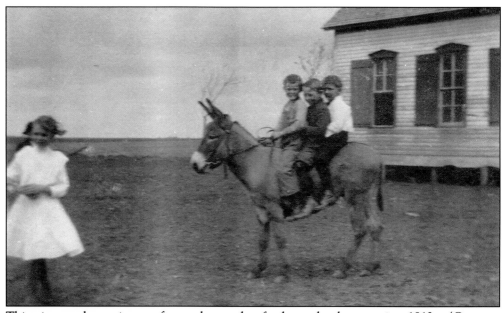

This is another picture from the end of the school year in 1912. (Courtesy Cynthia Trenckmann)

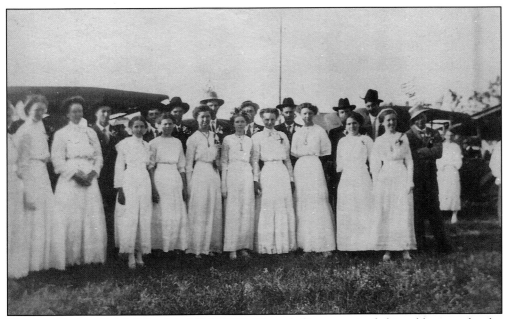

This was Turkey Creek School in 1911–1912. These ladies are quite fashionable, even for the countryside. (Courtesy Cynthia Trenckmann.)

These ladies are identified as Else, left, and Bertha. (Courtesy Cynthia Trenckmann.)

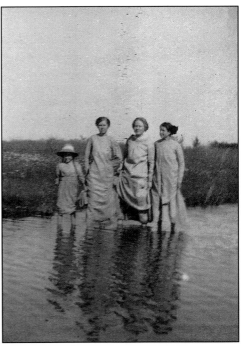

These individuals are wading in Turkey Creek. (Courtesy Cynthia Trenckmann.)

These ladies probably never operated this wagon. (Courtesy Cynthia Trenckmann.)

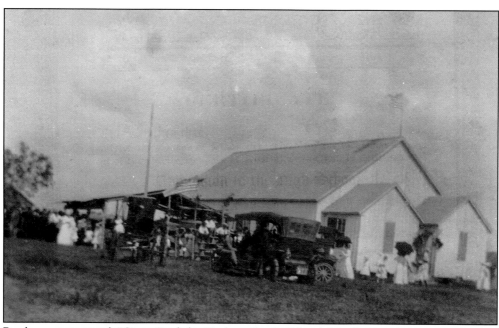

Bertha was crowned "Queen" of the Turkey Creek School Mayfest in the spring of 1912. (Courtesy Cynthia Trenckmann.)

Viola M. Luck graduated from Austin High School in about 1919.

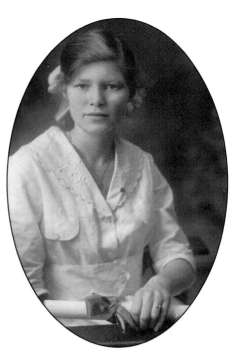

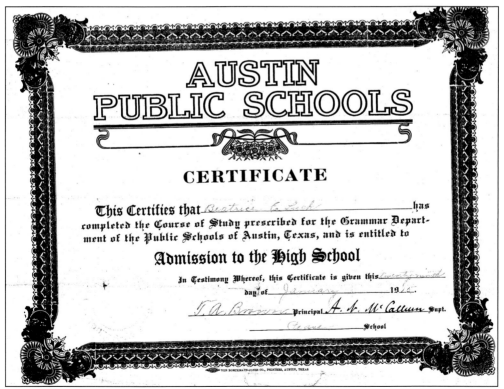

Beatrice Luck was admitted to Austin High School in 1915. Austin school superintendent A.N. McCallum, noted educator, served as superintendent for almost 40 years. A high school was later named in his honor.

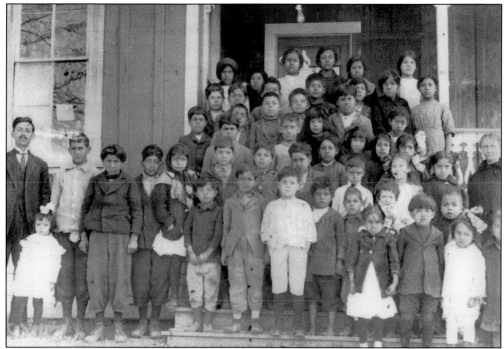

In 1916, the Mexican Baptist School opened at 301 East Avenue. It was a part of the First Mexican Baptist Church of Austin, which was originally organized in March 1899. At the far left is Rev. Daniel Sierra Barocio, church pastor. (Courtesy Danny Camacho.)

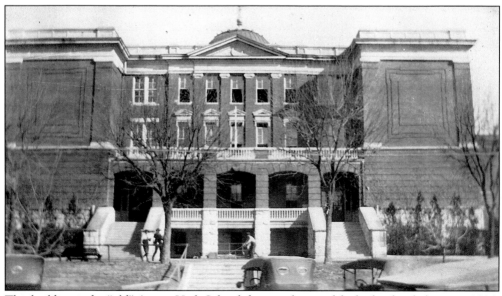

This building is the "old" Austin High School that was last used for high school classes in 1926. (Courtesy Ken Wukasch.)

Miss Viola Luck had only been out of Austin High School for one year when she began teaching at the Creedmore School in 1920.

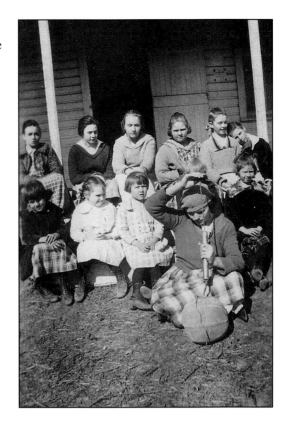

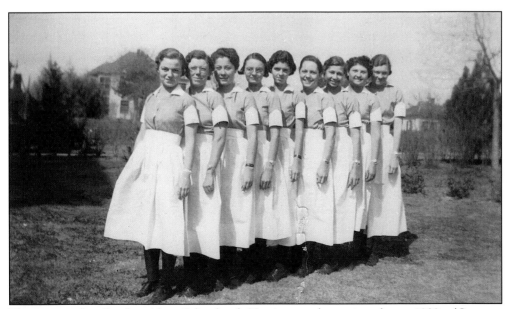

These are the Brackenridge School of Nursing students in about 1932. (Courtesy Christine Mason.)

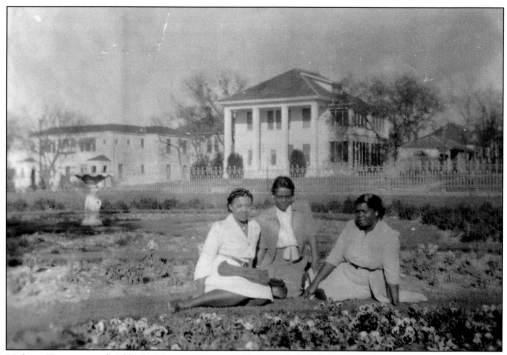

Helen, Fannie, and Alfreda Ussery, sisters, all attended Tillotson College in 1929. (Courtesy Ursula Carter.)

Thanks

TILLOTSON COLLEGE

$ 6 25 Tuition
3 50 Book bill

Austin, Texas, 2/28/ , 19 30

RECEIVED OF *Mrs. U. A. Ussery*

Ten Dollars DOLLARS

For Tuition Music Board Typewriting Fee Supplies Breakage Deposit

CHECK
MONEY ORDER
CASH

Bal. due on books $3 75

Treasurer.

In 1930, Mrs. U.A. Ussery paid $6.25 tuition for her daughter Alfreda to attend Tillotson College. (Courtesy Ursula Carter.)

Fannie Mae A. Ussery Lowe graduated from Tillotson College and became a librarian at the "colored" Anderson High School. (Courtesy Ursula Carter.)

Form A-4

AUSTIN PUBLIC SCHOOLS

TEACHERS' CONTRACT

Mrs. Fannie Low Austin, Texas, May 28 1941

Dear.. Mrs.. Low:..:

This is to notify you that you have been elected to a position as... teacher
in the public schools of the City of Austin for the school year, 1941 to 1942, subject to
assignment by the Superintendent and the Committee on Teachers.

Your salary has been fixed at $.. 100.00 - 9½ months.. per month. It is understood that you
are to perform your duties faithfully and satisfactorily and to comply with the rules and
regulations of the Board of Trustees, which are specifically a part of this contract.

Failure to sign and return acceptance WITHIN ONE WEEK from date of this notifi-
cation will be considered by the Board as a declination of the appointment.

By authority of the Board of Trustees,

Yours very truly,

A. N. McCallum
..
Superintendent

Mrs. Fannie Lowe was paid $100 a month to be a librarian at the "colored" school. (Courtesy Ursula Carter.)

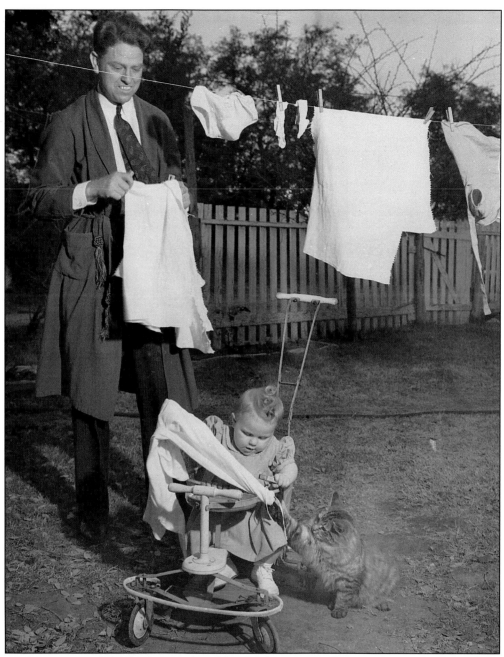

Dr. Dewitt C. Reddick (1904–1980) and his brother were orphaned at a young age, and they essentially supported themselves. Dr. Reddick earned many degrees, and was a professor of journalism at UT, retiring as professor emeritus in 1975. He wrote and edited many books, but always had time for family. (Courtesy Lel Hawkins.)

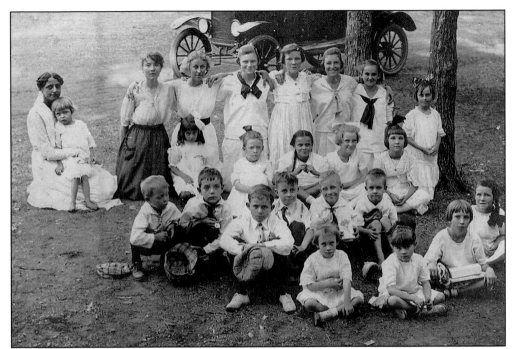

Pease School was the first Texas school built with public funds. It opened in 1876, and the Austin paper reported that "it is finely located, two stories high, with a basement, fitted up with recitation rooms and will accommodate 500 pupils." Trustee S.G. Sneed quoted the cost to be $20,376.13 with an additional $458.16 spent on a cistern and other fixtures. Pease School is still in operation.

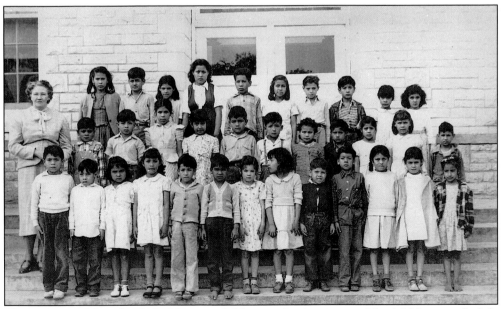

This was one of the schools for Mexican children in the Austin area. Mrs. McNeese, at far left, was the teacher. (Courtesy Frances Archer.)

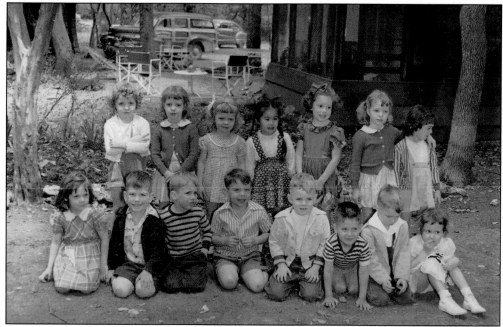

This is an Austin kindergarten in 1949 on Enfield Road. Pictured, from left to right, are as follows: (front row) Kathy Jackson, Ed ?, Joe Mack, Stephen Duval, Fred Connell, Jay Hamilton, Larry ?, and K. Acker. In the back row, from left to right, are Karen Dannelly, GeGe McCuiston, Phylis ?, Kay Wong, Peggy Scurlock, and Shelly McCuiston.

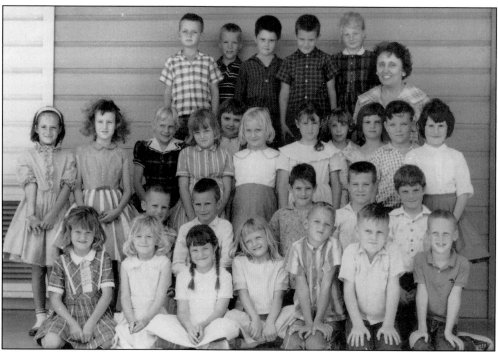

Mrs. Ruth Massey, teacher, is shown here with the Summitt School second grade class on May 10, 1963.